SHELTER cats

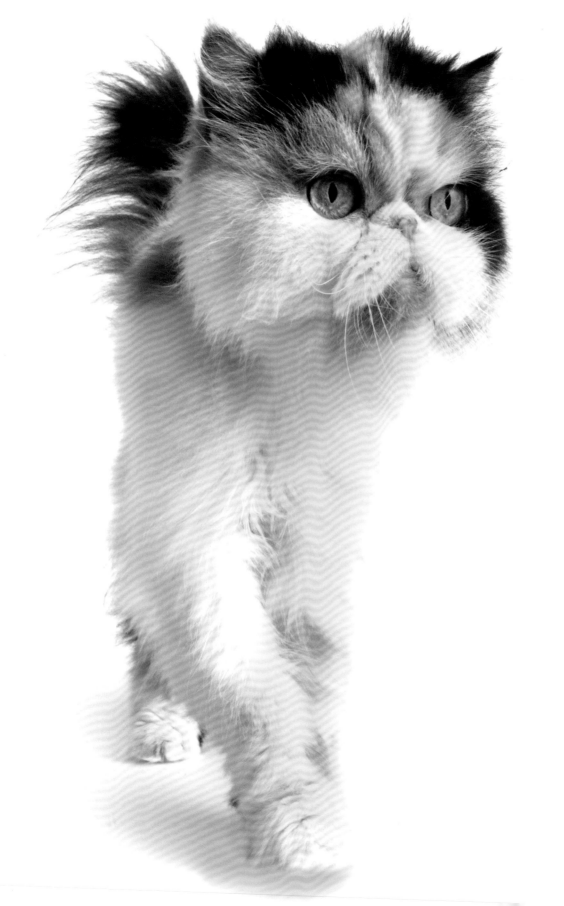

SHELTER cats

michael kloth

MERRELL
LONDON · NEW YORK

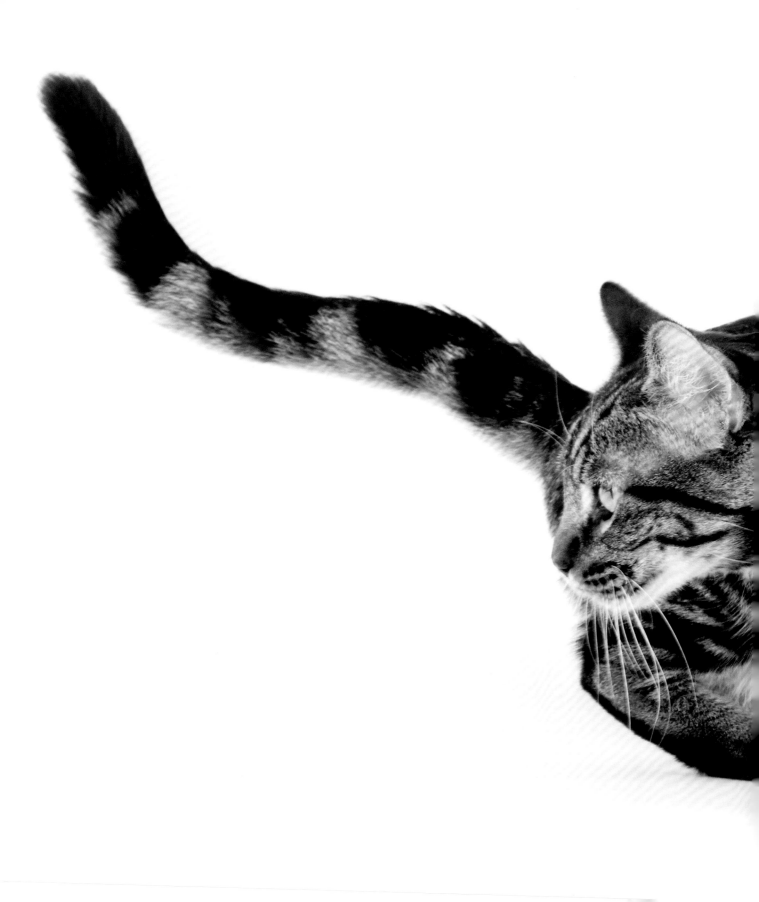

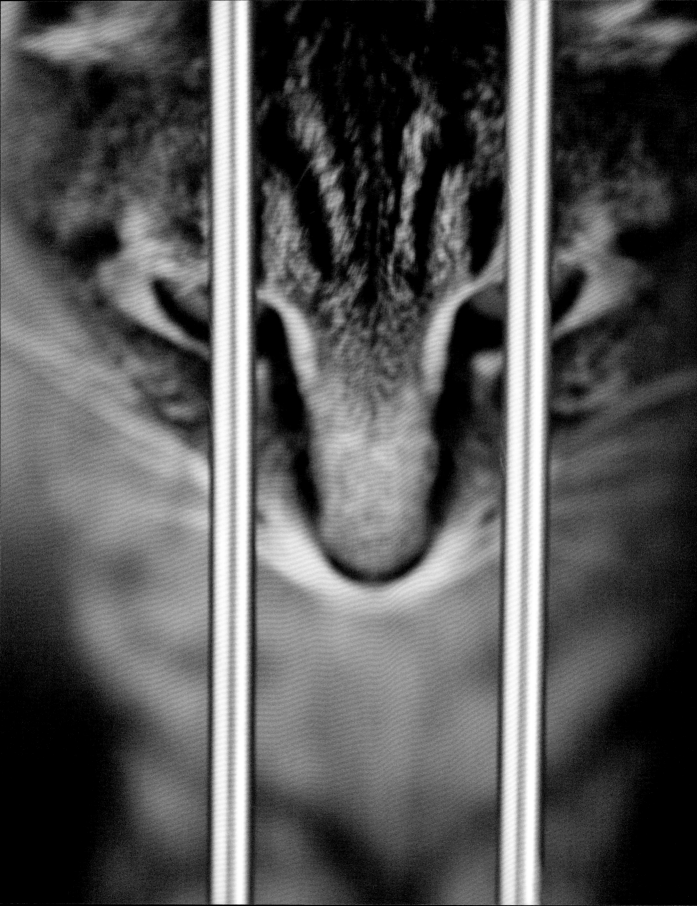

Introduction

If you take away any message from this book, I'd like it to be "adopt a cat." And if you take away a second message, it should be "spay or neuter your cat." I hope that, after meeting the cats featured in this book, you will agree.

Although I've always been an animal lover in a general sense, I've tended to think of myself as a dog person. So it came as a bit of a surprise that events led me to create a book on cats. Photography is a second career for me, and it wasn't long after I purchased my first camera that I learned about the Woodford Humane Society in Versailles, Kentucky. Even from the beginning, I understood that a good photograph can greatly improve an animal's chance of being adopted, and I could see that pet-adoption websites were full of pictures that were poorly exposed, cluttered, or worse, showing a scared and frightened animal. It didn't take long for me to start volunteering my time, regularly photographing the dogs under the society's care. Of course, this isn't a book about dogs, and so there's more to the story. I eventually realized that, if anything, the cats needed my help even more than the dogs.

I consider myself fortunate to have had the opportunity to work with the animals and dedicated staff at Woodford. In many shelters across the United States, roughly half the animals brought in find a new home; the Woodford Humane Society, however, boasts a 90 percent adoption rate. Because of the commitment of the staff and the good resources at Woodford, it wasn't uncommon to see an animal available for adoption for months at a time, and occasionally even longer than a year. Having the same feline faces greet me week after week, I discovered that the cats often experienced a longer wait for a "forever home" than their canine counterparts. I realized that I needed to photograph them too, but I didn't know where to begin. While I've always admired cats, I didn't have a clue how to interact with them. There was a lot of trial and error along the way, and I'm afraid that I might have made more than one feline enemy for life in the process of trying to help them find a home. But just a few short years later, I find myself having photographed hundreds of cats. A little blood, sweat, and tears (the allergic kind) went into this project, and I'm very happy to report that the work has resulted in a lot of happy endings for the cats I've photographed. It's my hope that this book might bring a happy ending to many more.

At the time of writing, over 75 percent of the cats photographed for this book had been adopted. Sophie, pictured at the Tri-Cities Animal Shelter in Washington, was one of the unfortunate few cats that became ill and was humanely euthanized when she did not respond to treatment.

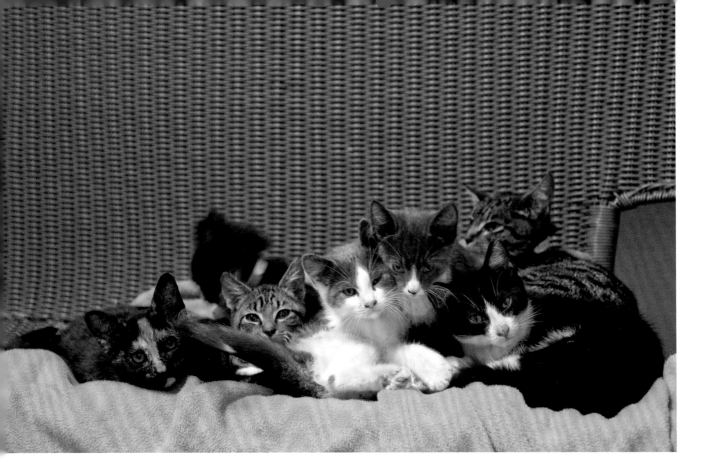

The Humane Society of the United States reports that American animal shelters care for between six million and eight million cats and dogs each year, but that only half of these animals ever find a home.[1] The staggeringly sad number of lives ended by euthanasia comes at an estimated annual cost to taxpayers of $2 billion.[2] Unfortunately, our feline friends make up a disproportionate number of these casualties. While dog adoption rates are on the rise, with a corresponding decrease in rates of euthanasia, cats are not faring nearly as well. In fact, even though the rate of cat adoptions is increasing, the rate of feline euthanasia is also going up.[3] More and more cats are entering shelters, but there are simply not enough people willing to make homes for them all.

There are over 90 million cats in American homes,[4] and cat owners tend to be among the most responsible of pet owners. More than 80 percent of household cats have been either spayed or neutered.[5] Since cat owners are already doing a good job spaying and neutering their pets, yet the number of cats brought to shelters is consistently high, we clearly need to look elsewhere for solutions. Tragically, less than 5 percent of lost cats entering shelters are ever reunited with their owners.[6] This statistic emphasizes the importance of microchip identification, especially for cats with outdoor privileges. The

It's hard not to smile when you walk into a room of kittens at a shelter and find a half-dozen or more snuggled together.

problem of cat overpopulation rests largely with feral cat populations and the 20 percent of household cats that are not spayed or neutered.

A breeding pair of cats and their offspring, when left unchecked, can produce 420,000 cats in seven years.[7] Of course, this is mathematical theory, and doesn't take into consideration real-life variables; however, it does underscore the need for action. In reality, if the cycle is not broken by human intervention, a pregnant cat and her offspring can be expected to produce a few thousand cats over the course of their lifetimes. These figures illustrate the importance of trap-neuter-return programs. Feral cats do not typically make good candidates for adoption as pets, and it has proven ineffective simply to remove them from an environment, because other cats will move in to fill the void. Trap-neuter-return programs, in which feral cats are caught, sterilized, and returned to their environment, have been shown to be an effective means of controlling the feral cat population.

My message is a crucial one: we must be responsible stewards for the animals in our care. Not only do we have to look after the pets that we know and love, but also we need to examine the bigger picture. In our consumer society, we are continually encouraged to buy the latest product with

Lola remains one of my few "failures" in photographing shelter cats. Having attempted to photograph her in my studio, I spent ninety minutes trying to coax her out of various hiding places, but came away without a usable portrait.

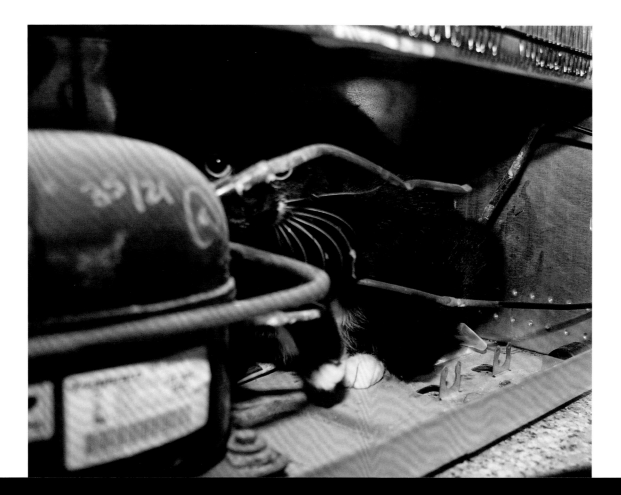

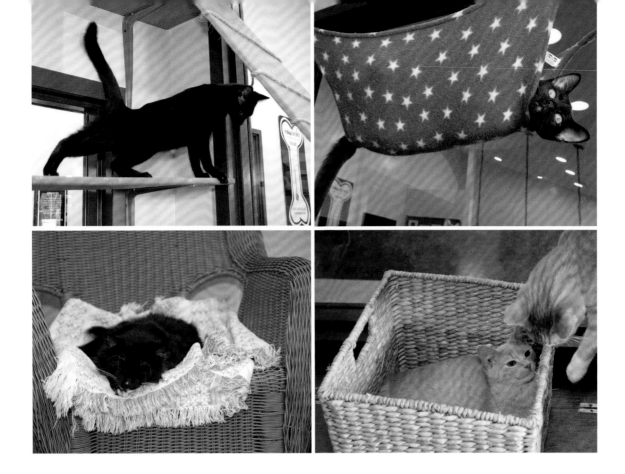

the cool new features, while yesterday's model is sent to the landfill. Sadly, we are guilty of adopting more or less the same attitude toward our pets. Although we are learning to recycle our waste, there are still too many of us who treat our pets as disposable, and take them to animal shelters, or worse, when it's no longer convenient to keep them at home. While our attitudes toward animal welfare are gradually changing for the better, our treatment of cats appears to lag behind that of dogs.

There are roughly the same numbers of cats and dogs kept as pets, so we might wonder why this difference exists. I think there are multiple issues that combine to play a role in the adoption rates. Among the problems may be the long-standing public perception of cats and cat owners. Indeed, as far back as 1904, a study of these perceptions brought to light the fact that people believe that dogs are more "manly" than cats.[8] I would like to believe that our opinions have evolved since that time, but cats are still in need of a public relations overhaul. Even our metaphors tend to put cats in a bad light. After all, isn't it better to have dogged determination than it is to be catty? And aren't dogs considered brave and loyal, while cats are sneaky and conniving? I think that these perceptions might play a role, but more likely it is the

Top left and right, and bottom right: Cats at the Woodford Humane Society, Kentucky, enjoy plenty of space to play and lots of great napping spots. Bottom left: A cat snoozes in the new adult cat room at the Tri-Cities Animal Shelter.

independence and self-reliance of cats that work most against them, at least in terms of successfully being reunited with their owners when they find themselves in an animal shelter. Many cat owners grant their pets outdoor privileges, and so it's not uncommon to see a cat roaming a neighborhood. Cats are left to their own business, with the assumption that they will soon enough find their way home. On the other hand, a dog on the loose is assumed to be not only an escapee, but also not clever enough to stay out of trouble. We tend to take immediate action when we see a dog roaming free. A further complication is the fact that a cat is generally so adept at outdoor survival that she may be on her own for weeks or months before anyone even realizes that she might not have a home—by which time her owners may have given up checking in with their local shelter.

Photographs like this one often appear on the adoption pages of a shelter's website. Such images do little to show a cat's personality, and instead rely on guilt to bring potential adopters to the shelter.

No matter how a cat finds her way to an animal shelter, there are no guarantees that she will either return to her old home or find a new one. And while cats at "no-kill" organizations are virtually guaranteed to find a home, they often face a long wait, living in only a small cage for the duration. Improved facilities, offering cat colonies where cats can cohabit and have room to play with

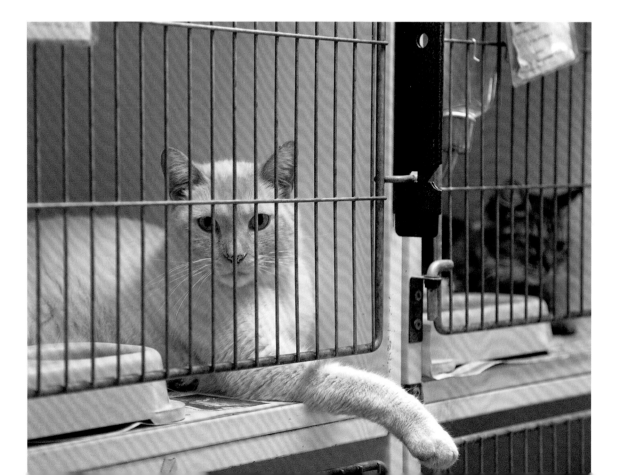

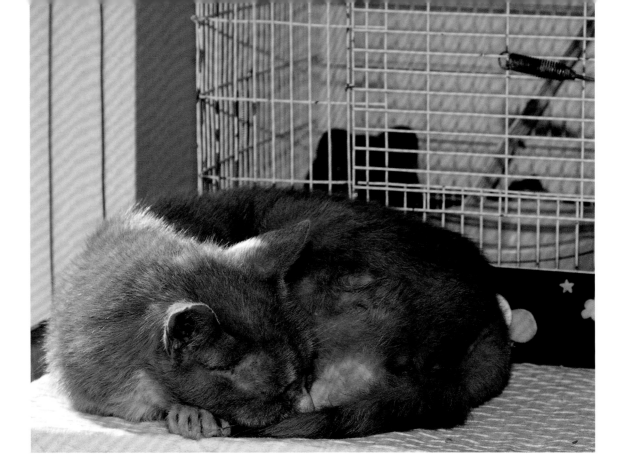

one another, are becoming more common; but, sadly, the less-fortunate cats at many shelters live in small cages until they are adopted, are humanely euthanized, or are transferred to research facilities.

As I learned early on, taking a good portrait of a cat can be a difficult proposition, and it's no surprise that many shelters post poor-quality photographs on their websites, or choose not to post any images of their cats. Yet a good portrait can make a real difference in getting a cat noticed and in inspiring someone to visit the shelter to meet the animal. In fact, I've seen double-digit increases in adoption-page visits since I've been photographing the animals at the Benton-Franklin Humane Society in Kennewick, Washington. Enticing people to look at adoptable cats is the first step in getting them to consider adoption.

Photographing cats is, to put it euphemistically, a dynamic experience. I've been scratched, peed on, and bitten. I've also experienced feline affection, joy, and gratitude for offering attention. It would be infinitely easier to photograph the cats in their cages, but I firmly believe that cage portraits encourage decisions based on guilt and pity. I work to portray my subjects in playful, dignified portraits

Thomas, mascot at the Benton-Franklin Humane Society in Washington, curls up in front of a cage of hamsters. Seconds later, he was startled by a hamster poking him in the back.

that allow potential adopters a glimpse of their new family member's personality. Perhaps ironically, it was only as I began this book that I started to create compelling imagery of my subjects living their lives at animal shelters. Almost immediately, I noticed that melancholy images of cats in cages invoked a very different response from viewers, compared to pictures of the same cats shot in my portable studio setup ("What a beautiful cat," rather than "Oh, poor kitty"). I think this informal observation confirms the importance of my approach.

A feral cat enjoys a few bites of kibble outside the Woodford Humane Society. She is a graduate of the society's trap-neuter-return program.

There are many ways to make a difference in the life of a humane society animal, and we may each have our own way to share. My way is through my photography, and although many people assume that animal shelters are depressing, I choose to work from a happy place. There seems to be a misconception that artists need adversity in order to flourish. I can't deny that working with adoptable animals is frequently emotionally difficult, and it's very hard to learn that one of "my" cats has been put to sleep. My work with shelter cats can be poignant, but, more often, I strive to express my subjects in a fun and spirited manner. My goal is to inspire people to consider adoption as a first choice, and to encourage them to visit local shelters. My subjects can be graceful or goofy, delightful

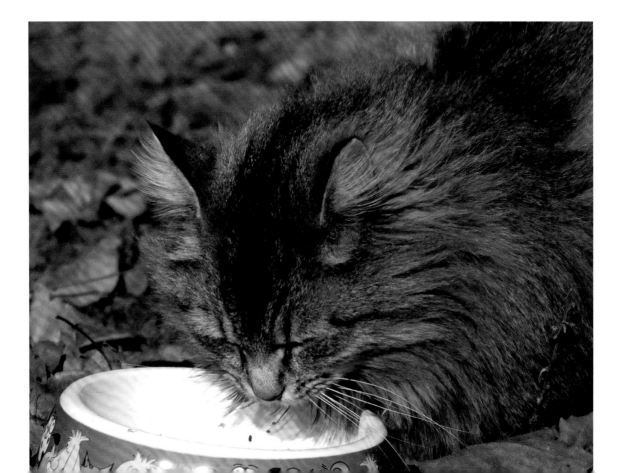

Below: A mother cat and kittens wait to be adopted at the Tri-Cities Animal Shelter. Opposite: A resident of the Tri-Cities Animal Shelter's adult cat room. Long-term residents have been moved to a room where they can interact with one another and with potential adopters.

or dignified, but mostly they are grateful for the attention that I offer and for a chance to stretch their legs and play for a while outside their cages.

Our treatment of homeless animals may have improved greatly over the last hundred years or so, but we still have a long way to go. New York and other cities are shining examples, reducing euthanasia rates at their municipal shelters by offering free or low-cost spay/neuter services.[9] The solutions that work for a large city are not necessarily the same as those that work for small rural communities, but the lessons learned in New York should be adapted elsewhere. I certainly don't pretend to have all the answers, or even many of them. I am convinced, however, that if we all do our part, we can make a difference to the lives of homeless cats, and we can reduce the numbers that never find a home. So, as I invite you to enjoy these portraits of shelter cats, I ask you to consider adopting a cat or becoming involved with your local humane society or animal shelter.

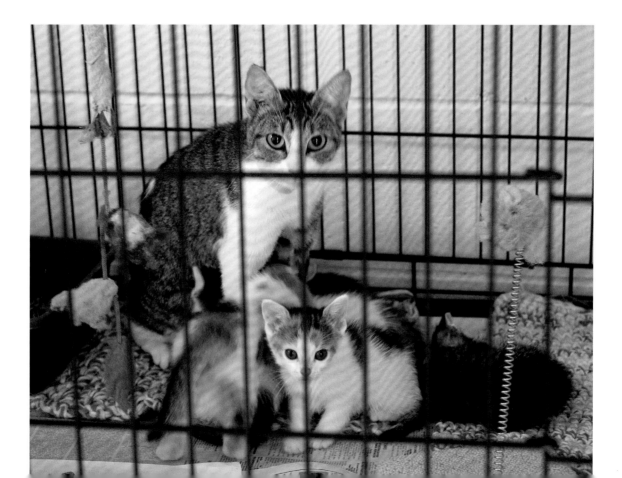

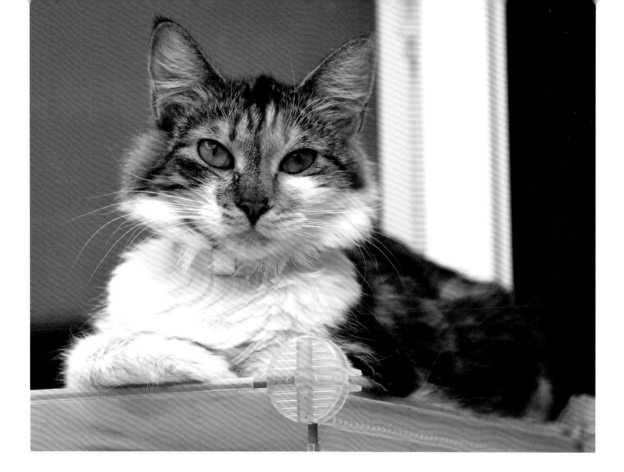

Notes

1 "Common Questions about Animal Shelters," The Humane Society of the United States (HSUS), October 26, 2009, http://www.humanesociety.org/animal_community/resources/qa/common_questions_on_shelters.html (accessed 3/21/10).

2 "Affordable Spay/Neuter Bill for Cats and Dogs," Change.org—Animals, http://animals.change.org/petitions/view/affordable_spayneuter_bill_for_cats_and_dogs (accessed 4/19/10).

3 Linda K. Lord *et al.*, "Demographic Trends for Animal Care and Control Agencies in Ohio from 1996 to 2004," *Journal of the American Veterinary Medical Association* 229, no. 1, July 1, 2006: 48–54.

4 According to the 2009–2010 National Pet Owners Survey, conducted by the American Pet Products Association, there are approximately 93.6 million owned cats in the United States. See http://www.americanpetproducts.org/press_industrytrends.asp (accessed 4/19/10).

5 "Are Owned Cats Causing a Population Crisis?," National Pet Alliance, http://fanciers.com/npa/owned-cats.html (accessed 7/11/09).

6 According to the HSUS, 2–5 percent of cats entering shelters are reclaimed by their owners each year. See "HSUS Pet Overpopulation Estimates," November 23, 2009, http://www.humanesociety.org/issues/pet_overpopulation/facts/overpopulation_estimates.html (accessed 3/21/10). Lord *et al.*, *op. cit.*, found that 0.9 percent of all cats brought to shelters for any reason, and 1.3 percent of stray cats brought to shelters, were reunited with their owners.

7 Feral Cat Coalition, http://www.feralcat.com (accessed 3/21/10).

8 John C. New, Jr., *et al.*, "Birth and Death Rate Estimates of Cats and Dogs in U.S. Households and Related Factors," *Journal of Applied Animal Welfare Science* 7, no. 4, October 2004: 229–41.

9 See, for example, The Toby Project, http://www.tobyproject.org (accessed 7/19/09).

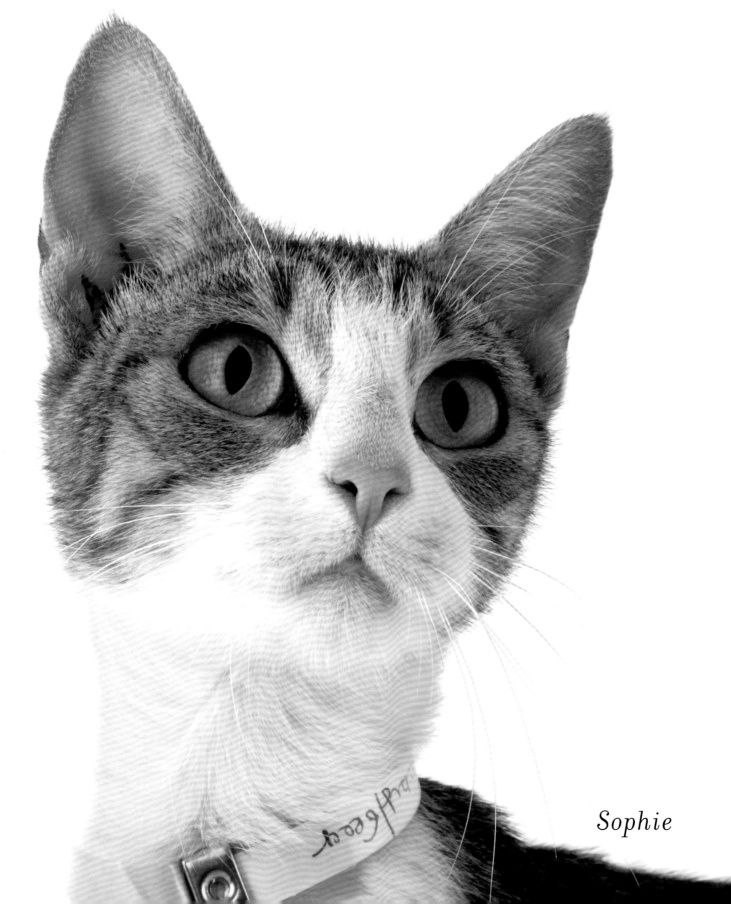

Sophie

Andy
Asparagus
Baby Girl
Billy
Binks
Black Jack
Bucket
Captain Hook
Casey
Charlotte
Clara
Finnegan
Garfield
Hope
Julius
Kahula
Karma
Kimba
King
Little Bug
Mary Anne
Misha
Miss Kitty
Mulan
Noble
Olivia
Ozzy
Peach
Peepers
Precious
Pumpkin
Radar
Rocket
Rocky
Sammy
Sasha
Sasquatch
Scarlet
Scotty
Skittles
Socks
Soda
Sonia
Sophie
Suey
Sulu
Sybil
Tango
Tiger
Trigger
Vegas
Willie
Wyatt

SHELTER cats

Mulan

Never has an animal more deeply and rapidly captured my heart. From the day I brought her home, she was mine and I was hers. Her gentle and sweet temperament is a perfect match for me.

Marla Gurr, Mulan's new owner

Misha

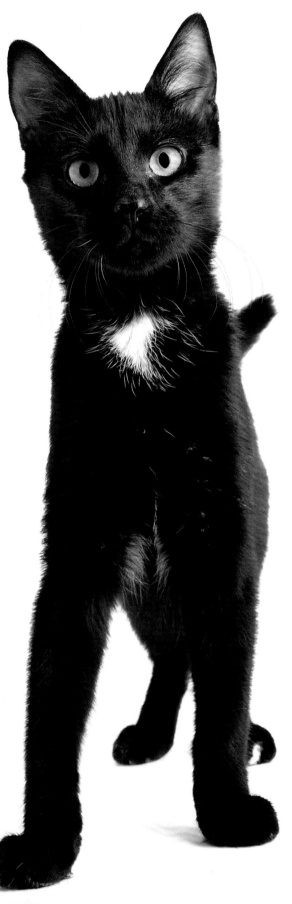

Black Jack

Trigger

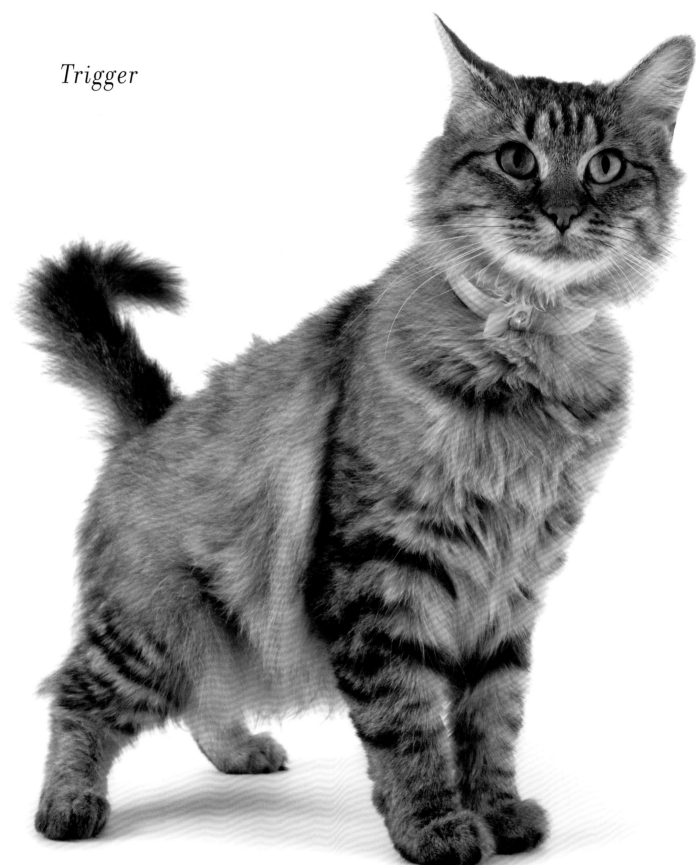

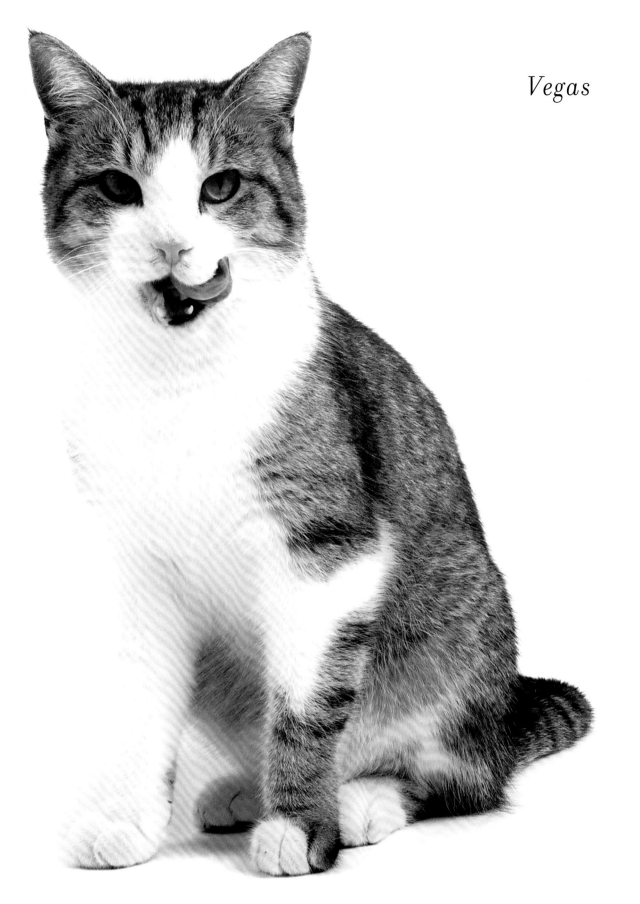

Vegas

Miss Kitty

Miss Kitty is a beautiful, sweet girl; I honestly have no idea why she was returned. Her adopter gave her to a friend and just told her to bring Miss Kitty back to us. She's a classic cat: charming, classy, and independent, but unfortunately still looking for the right home. She has a cute, high-pitched voice, and she's not afraid to reach out and take a swipe at you if she wants your attention.

Beth Oleson, Woodford Humane Society

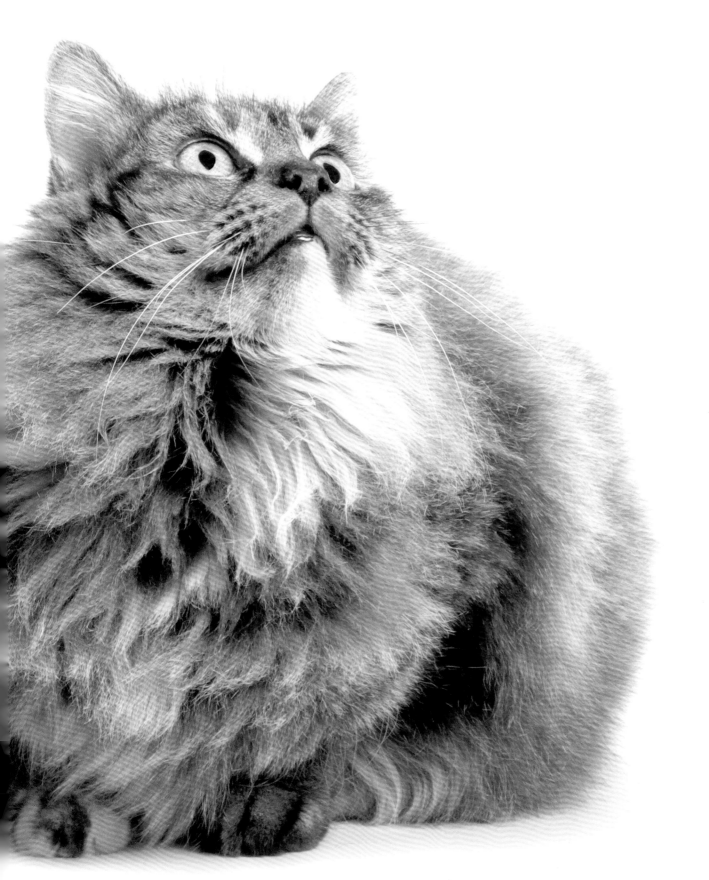

Kitten

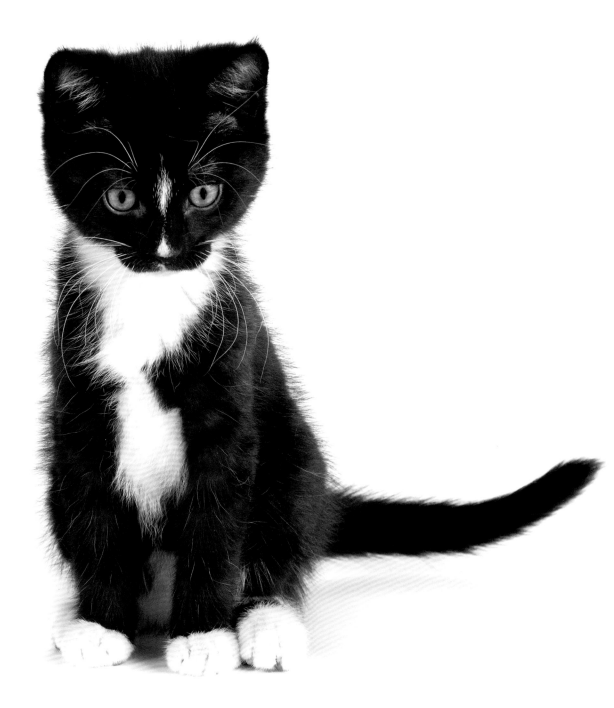

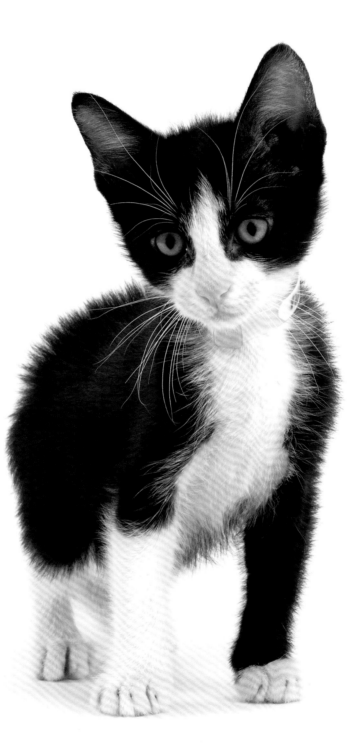

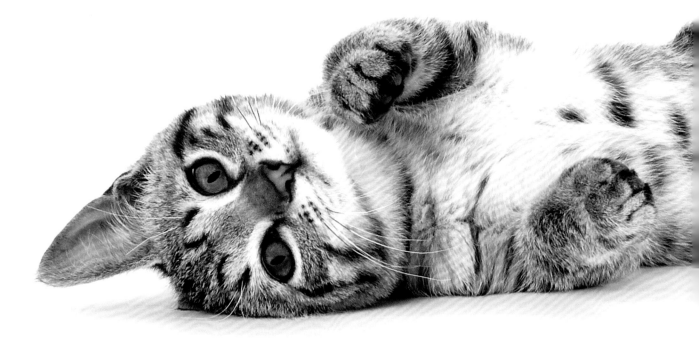

Little Bug

Ozzy

*Ozzy's story is a testament to the work
we do at our "no-kill" shelter. It sometimes
takes a long time to adopt out animals,
especially adult cats ... but once they are impounded
at the BFHS, they are here until their "forever home"
can be found. Ironically for Ozzy, that happened
shortly after the staff threw him a party
to celebrate the first anniversary
of his arrival at the shelter.*

*Ed Dawson, Operations Manager at the
Benton-Franklin Humane Society*

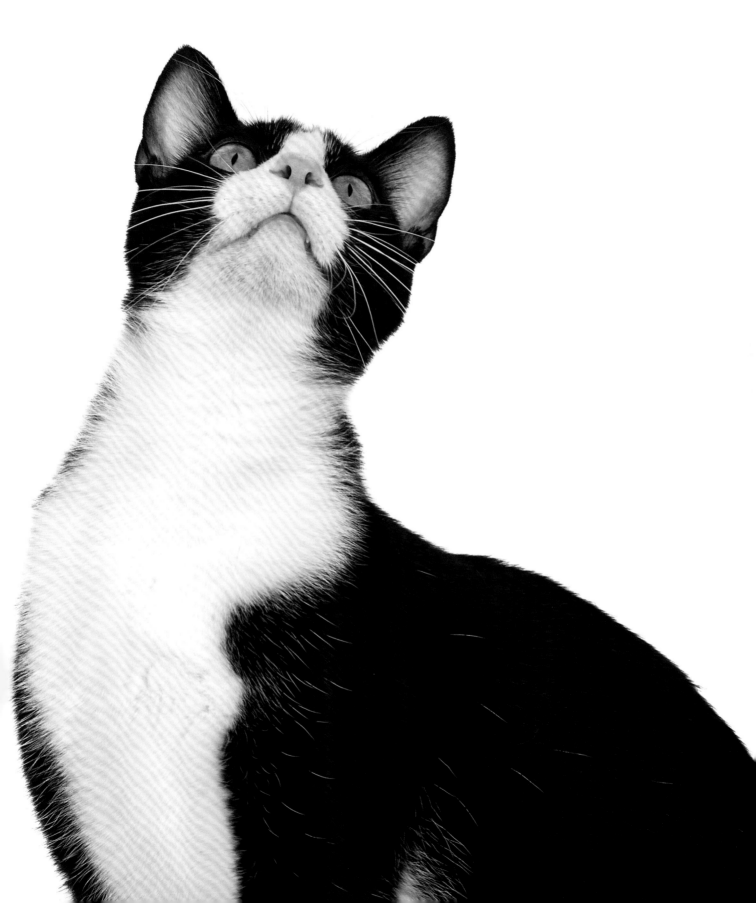

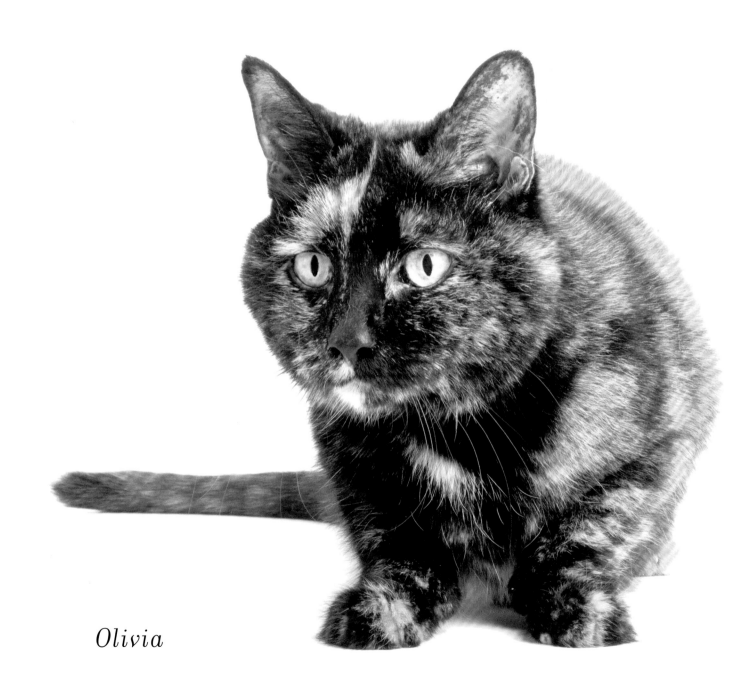

Olivia

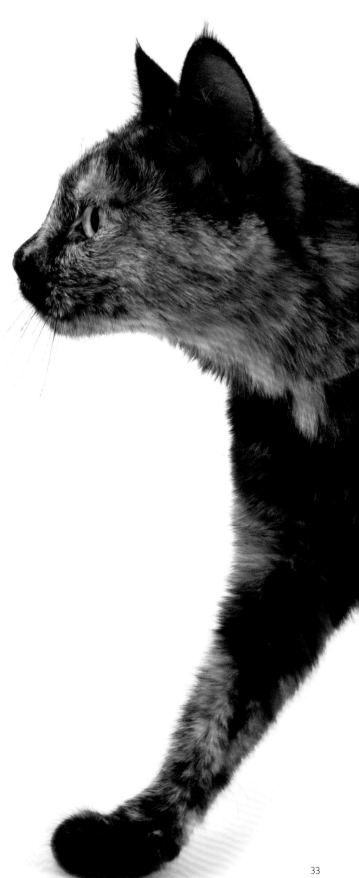

R3002

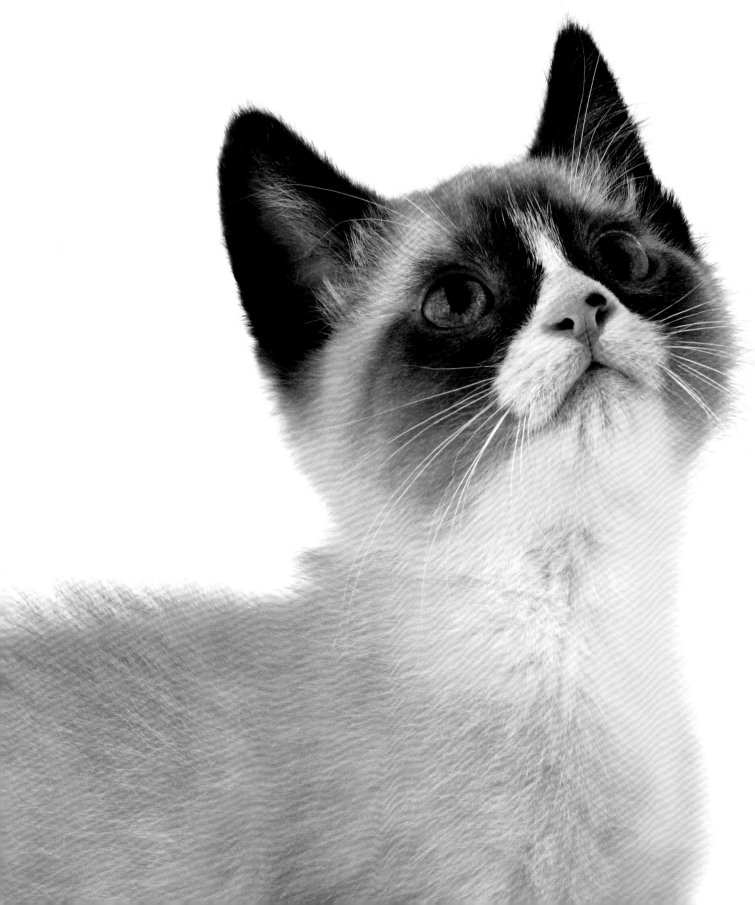

Sulu

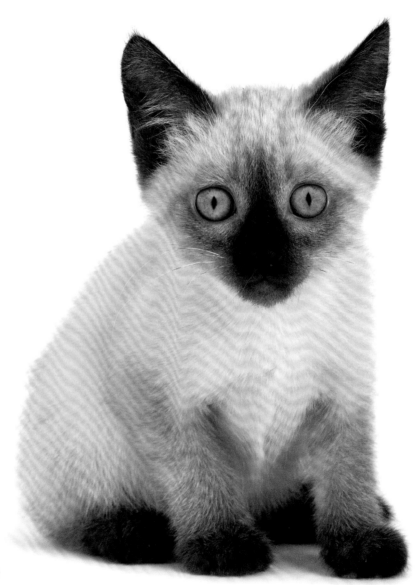

Puma's kitten

Binks

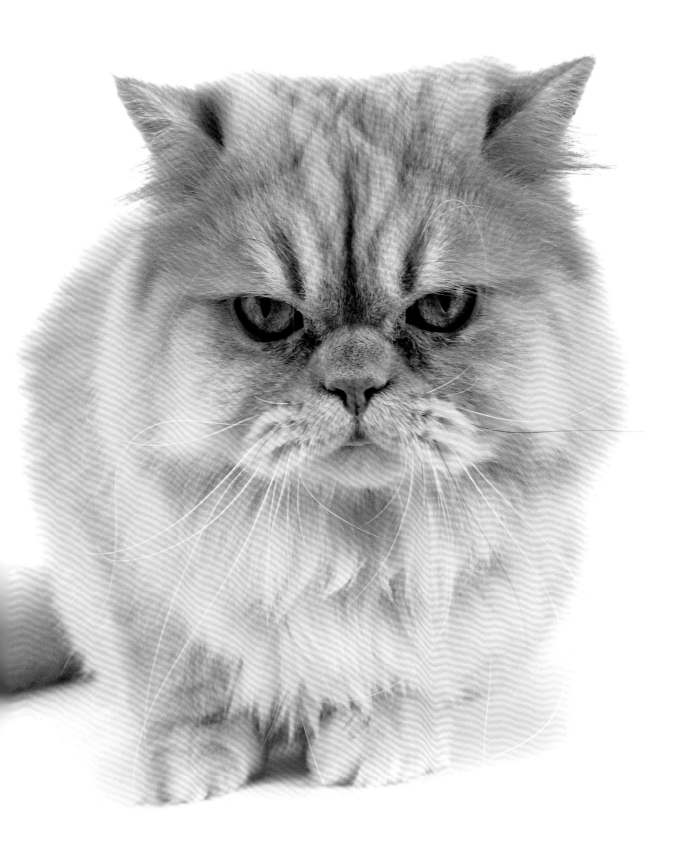

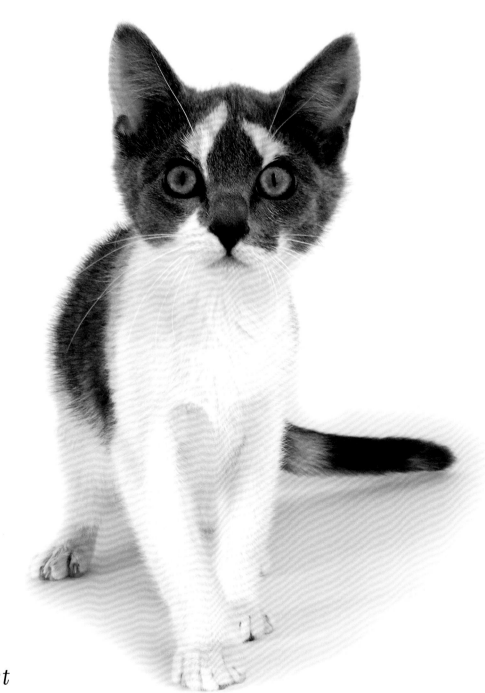

Bucket

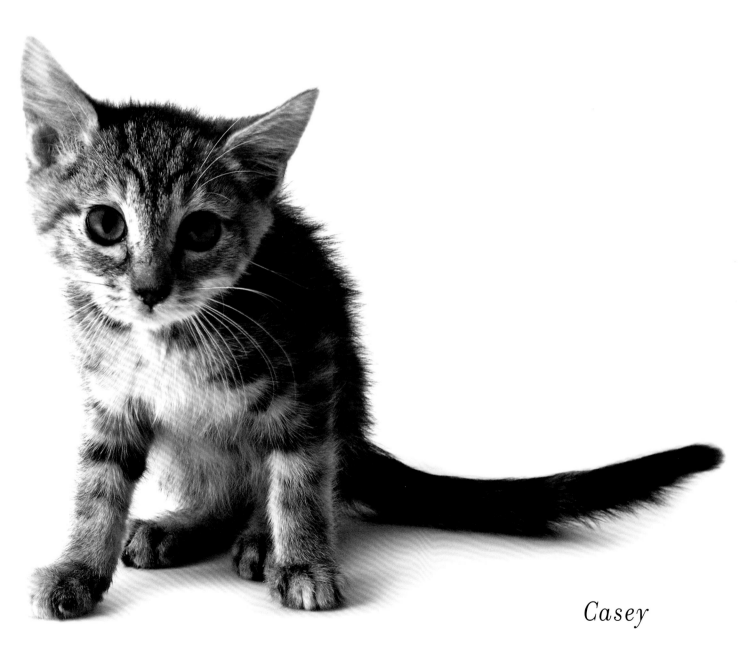

Casey

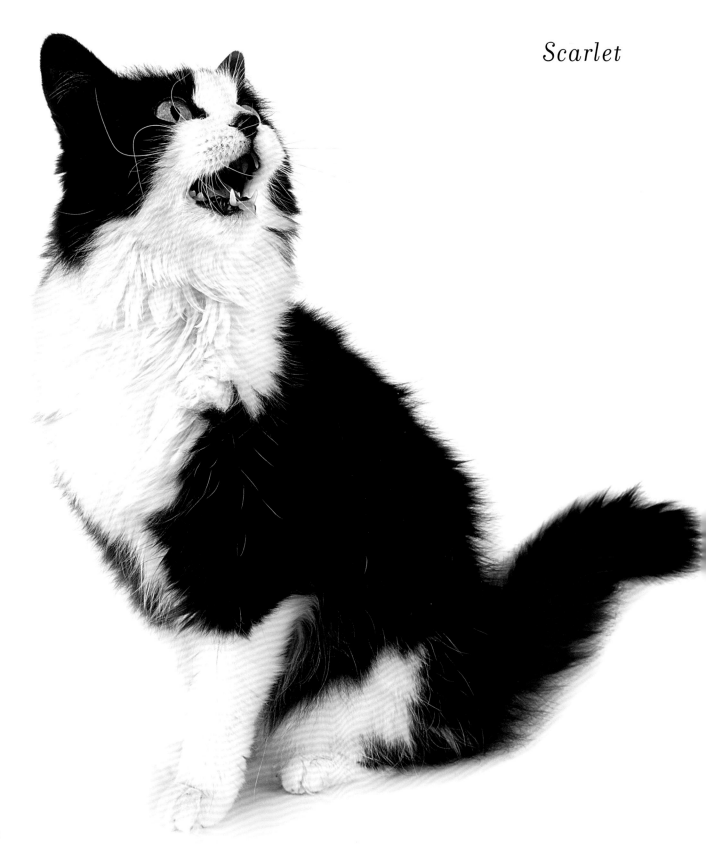

Scarlet

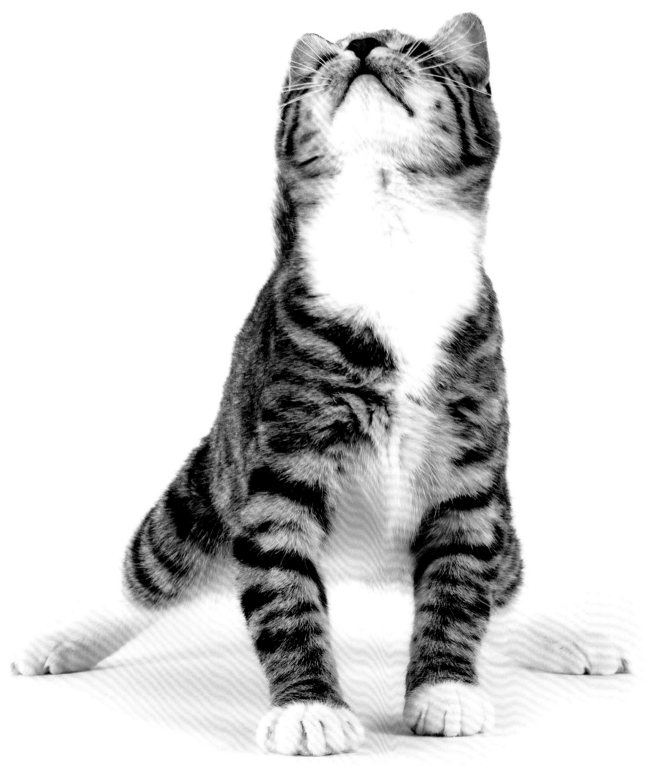

Clara

Kittens

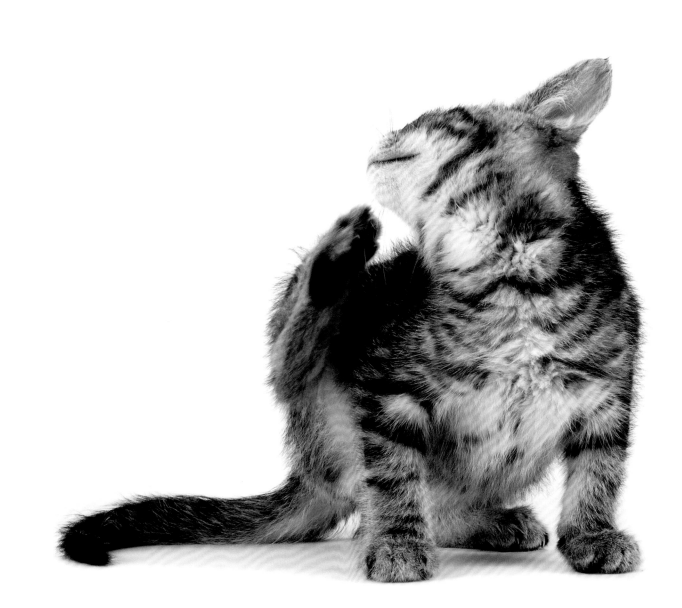

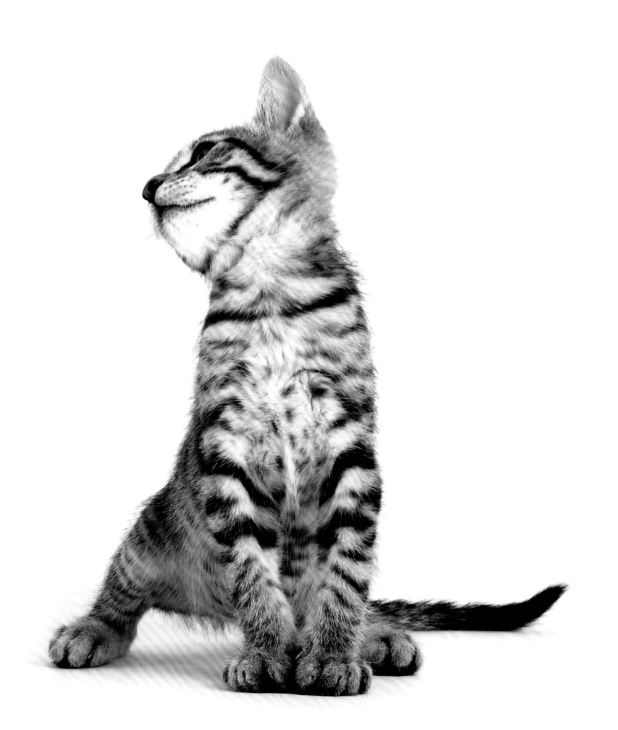

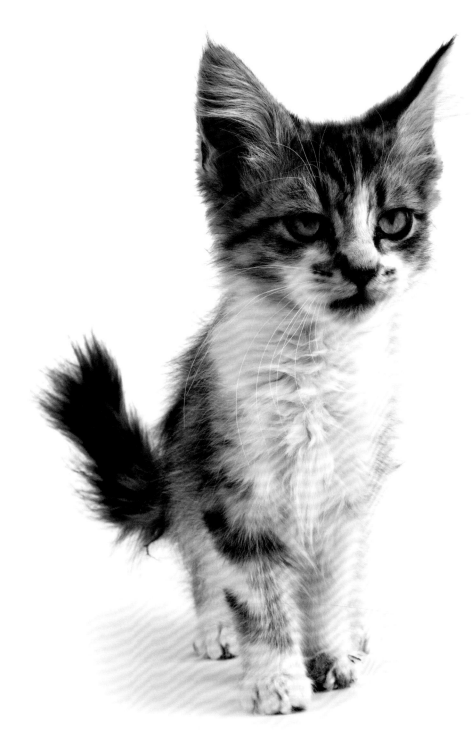

Kitten

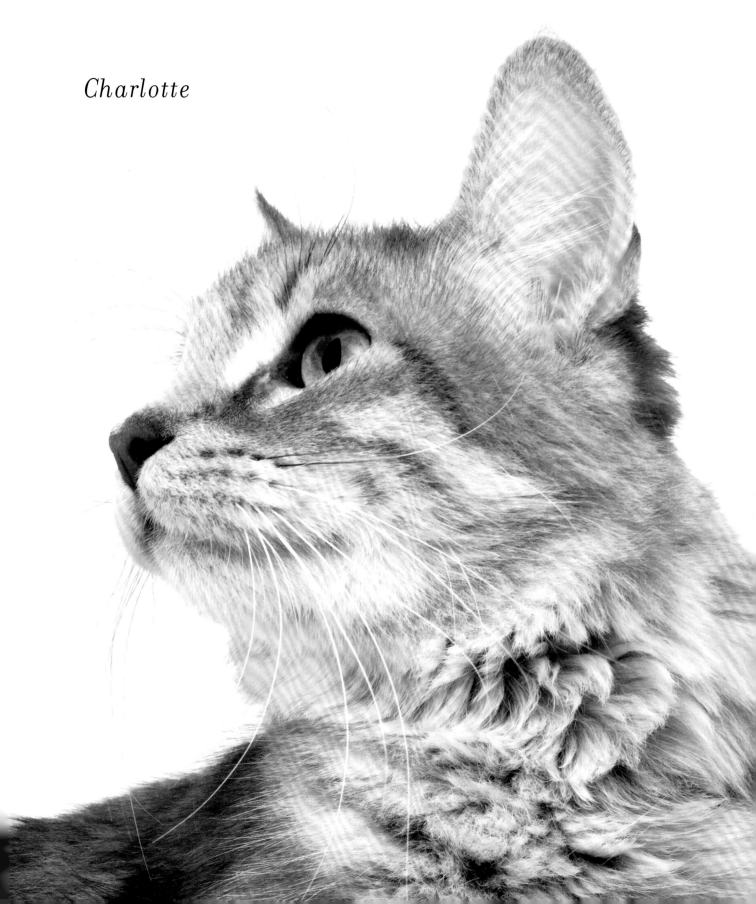

Charlotte

Billy

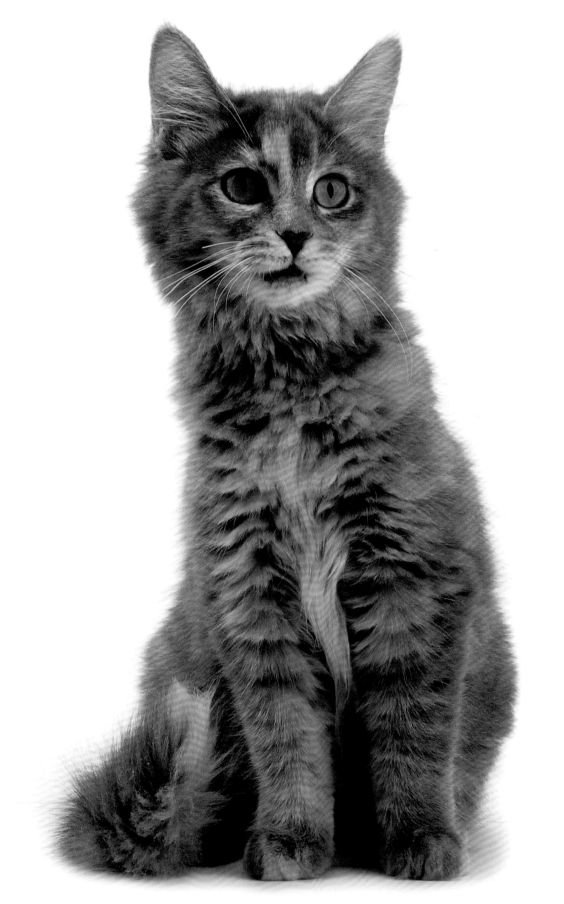

Asparagus

Finnegan

Adopting a pet from a shelter was a no-brainer for us. Choosing Finnegan was easy, too. With his beautiful blue eyes against his ivory coat, he is a joy to live with, and never fails to bring a smile to brighten our day.

John and Judy Geuther,
Finnegan's owners

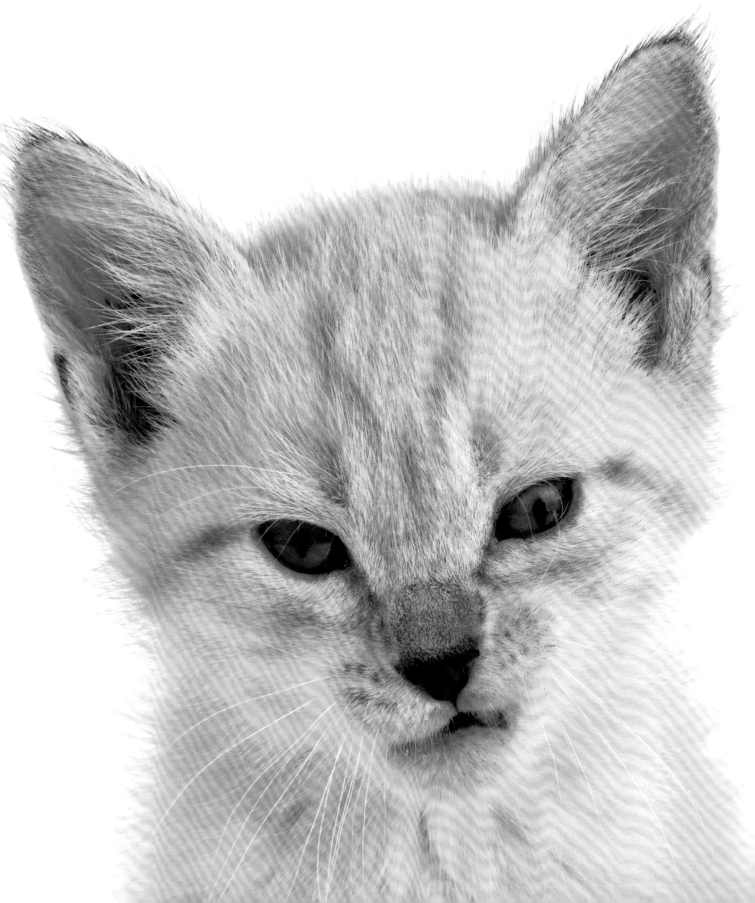

Kitten

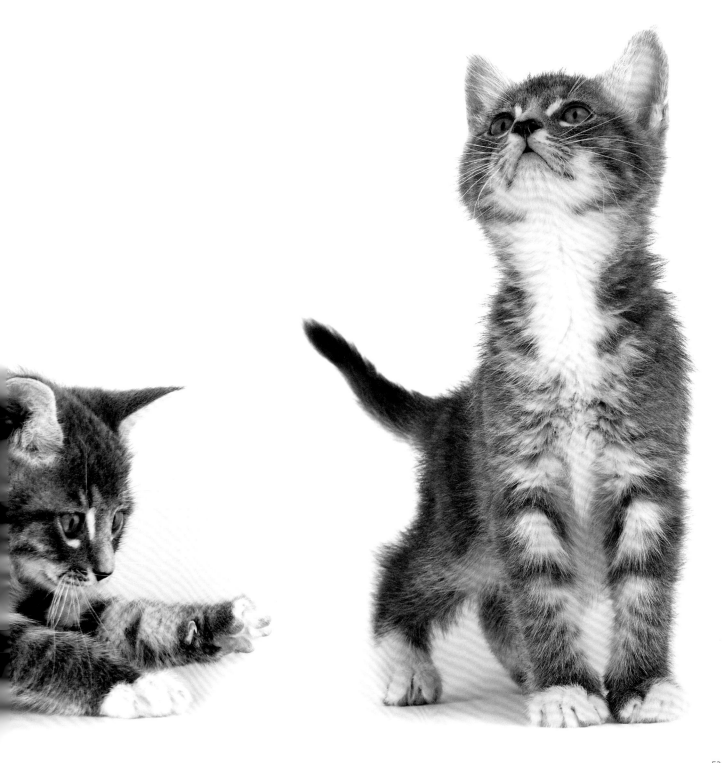

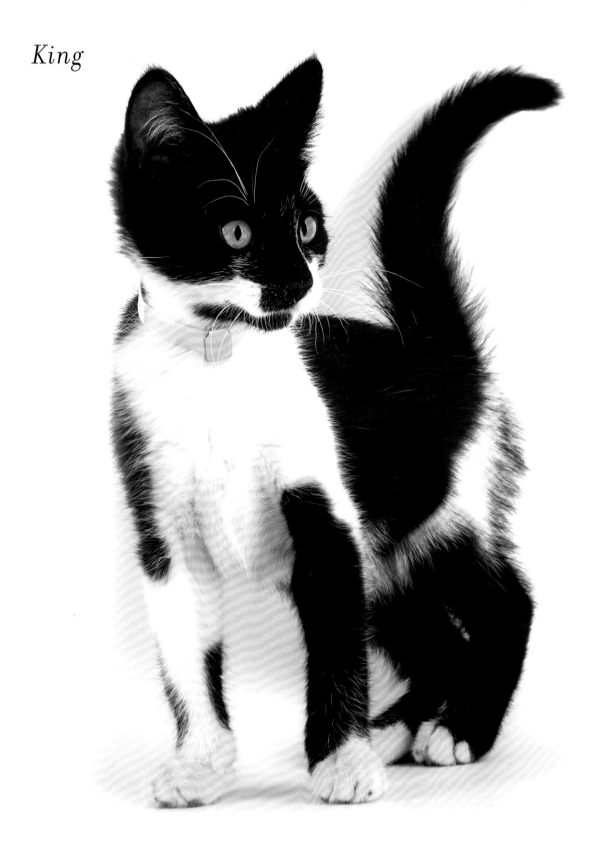

King

Manga's kitten

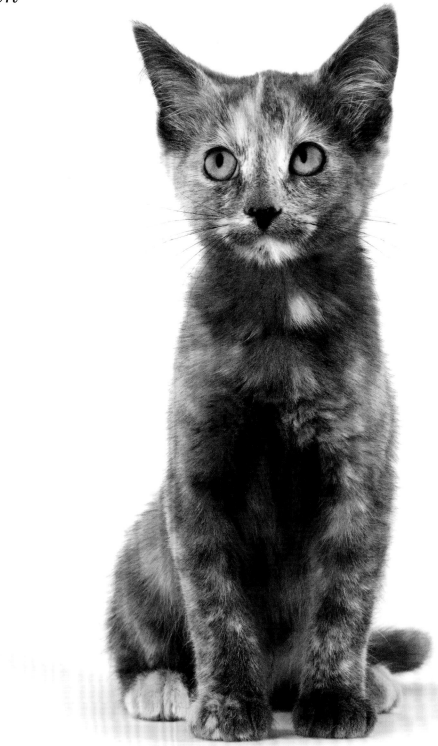

Manga's kittens

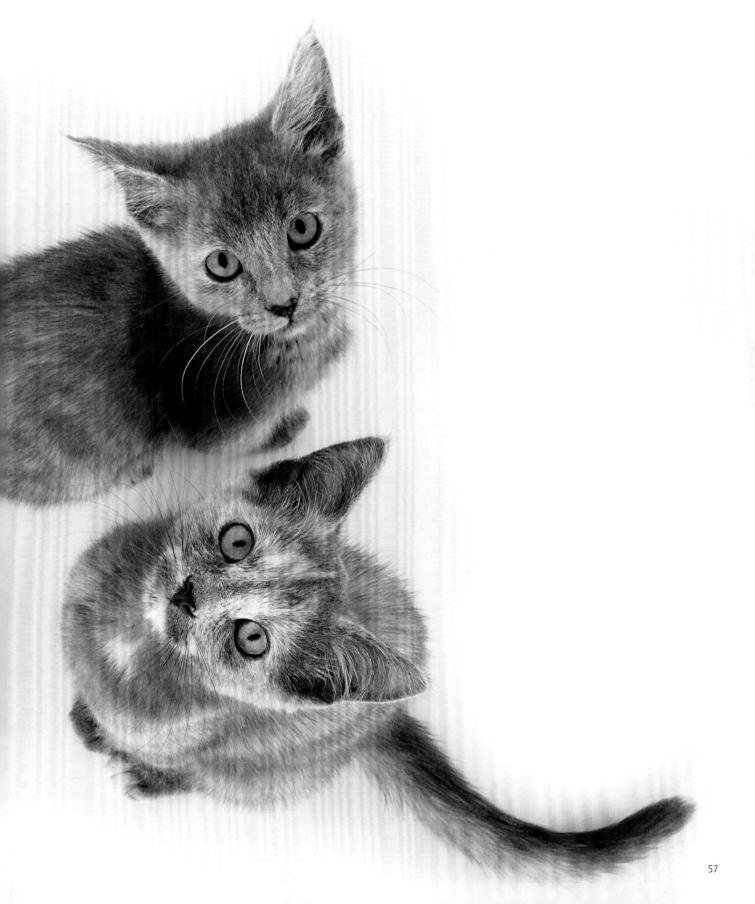

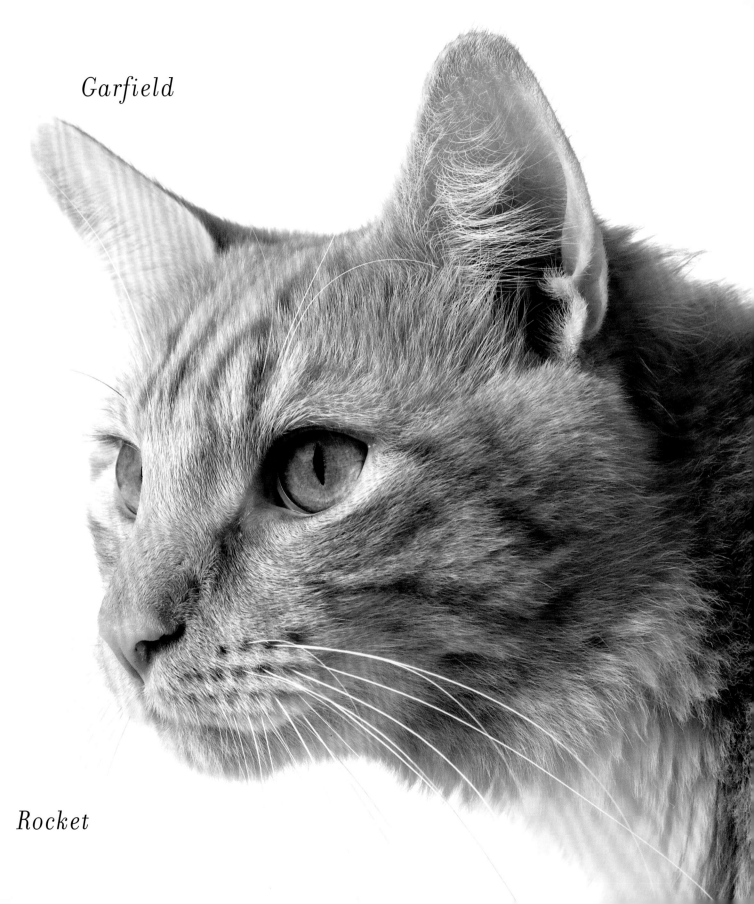

Garfield

Rocket

Kitten

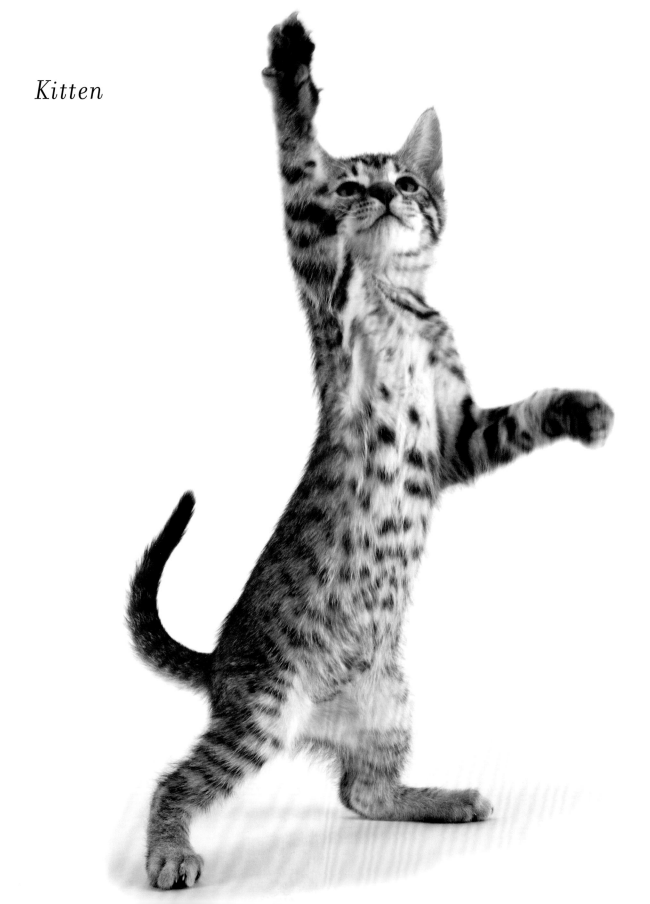

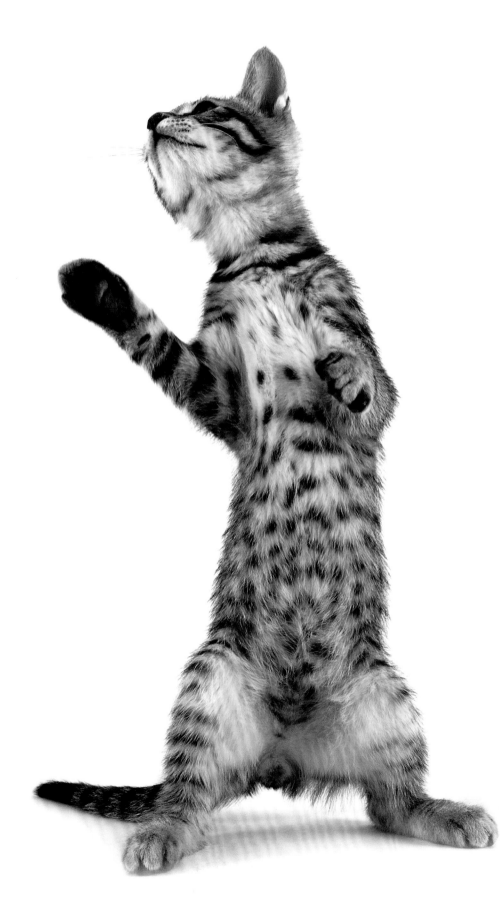

Pumpkin

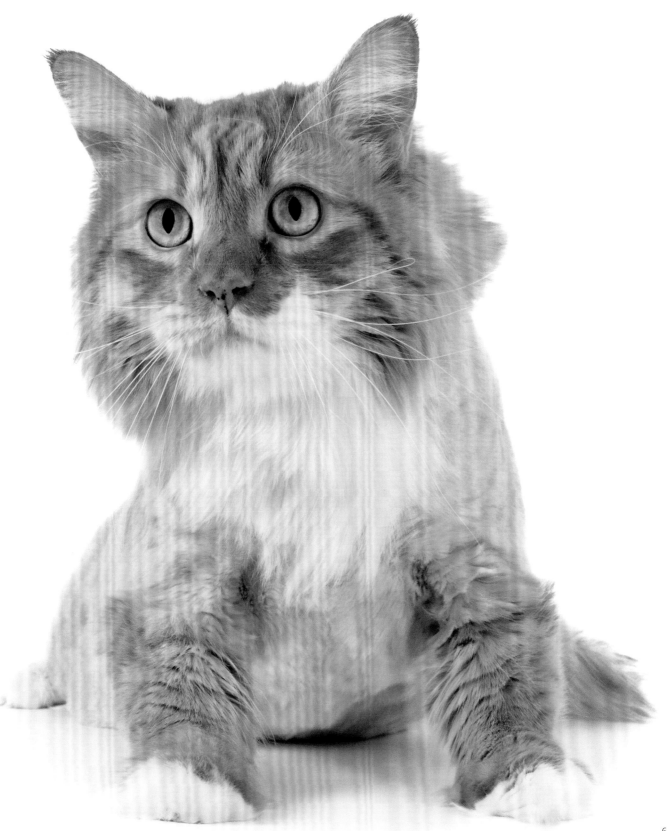

R3079 & Peepers

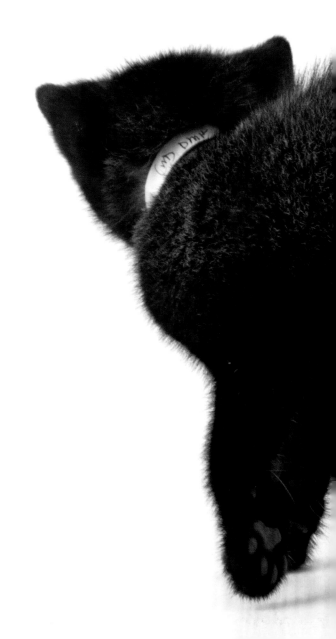

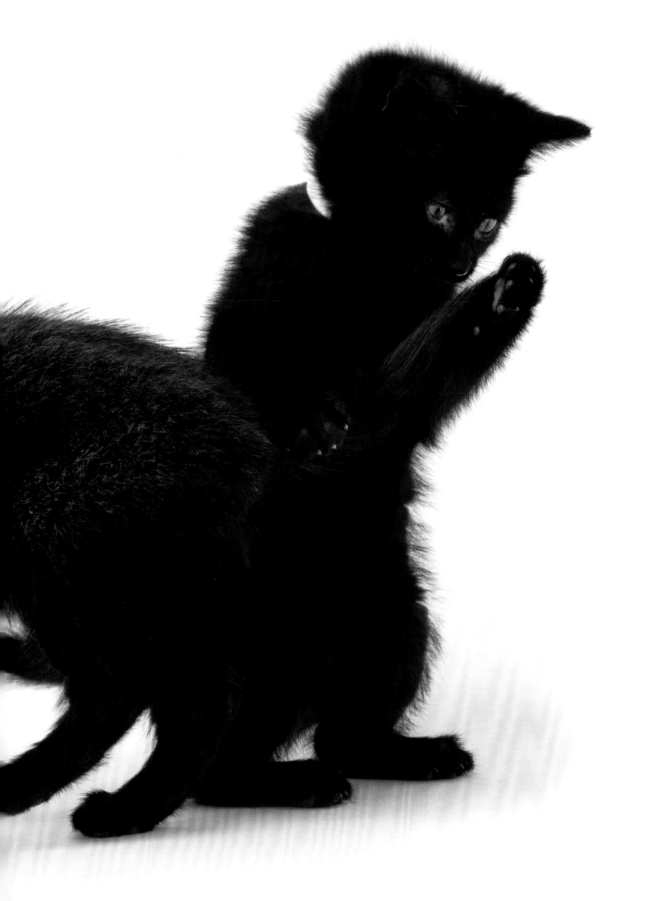

Soda

Mary Anne

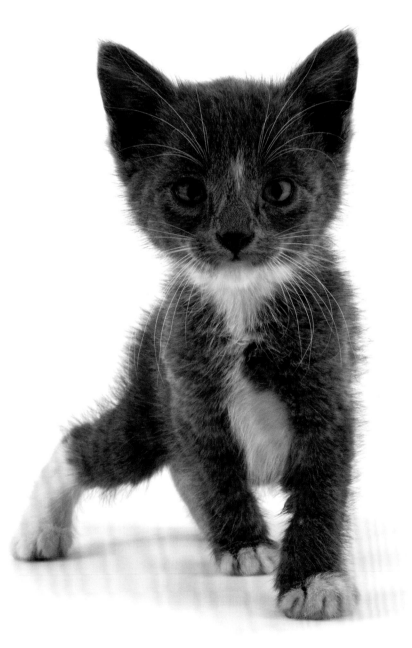

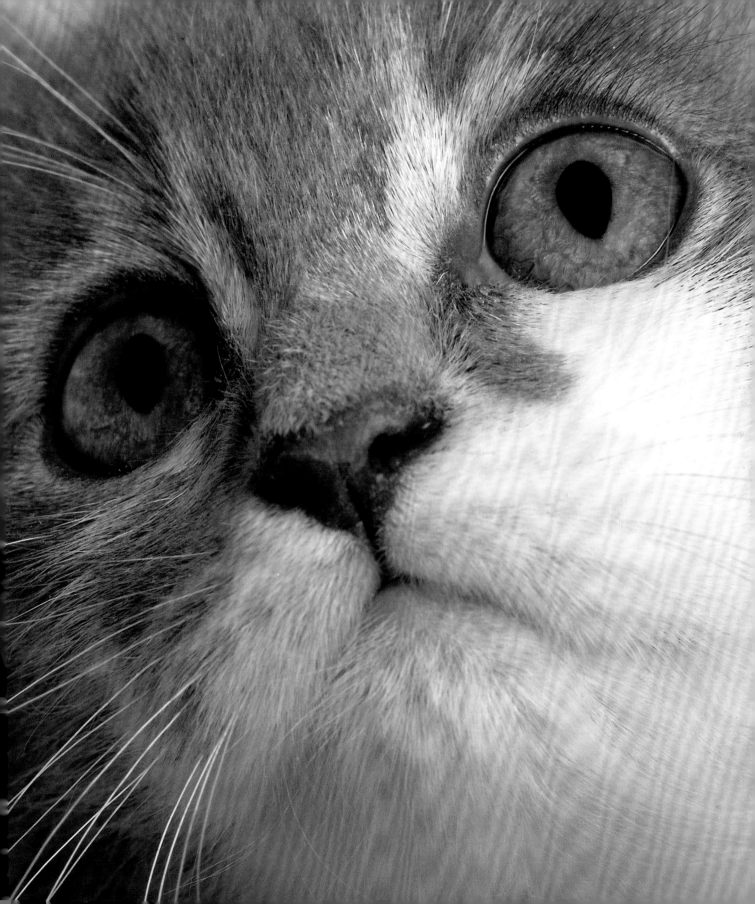

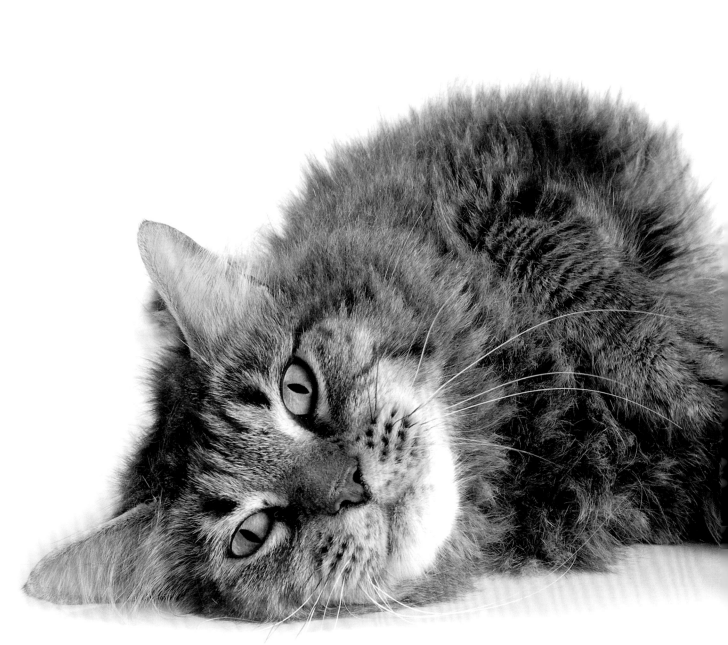

*While some cats use our sessions as a chance
to escape, Wy made the most of her photo opportunity.
She spent the entire time on my table, stretching
out and having a good scratch.*

Wyatt

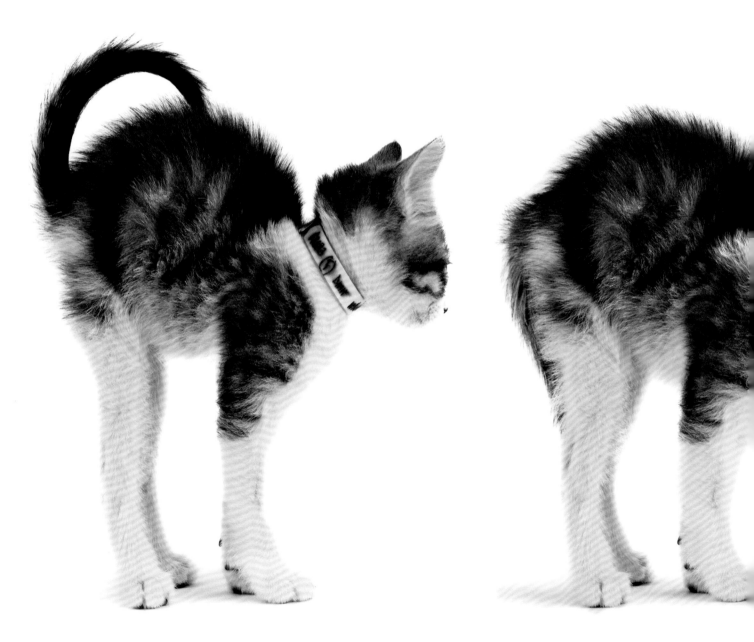

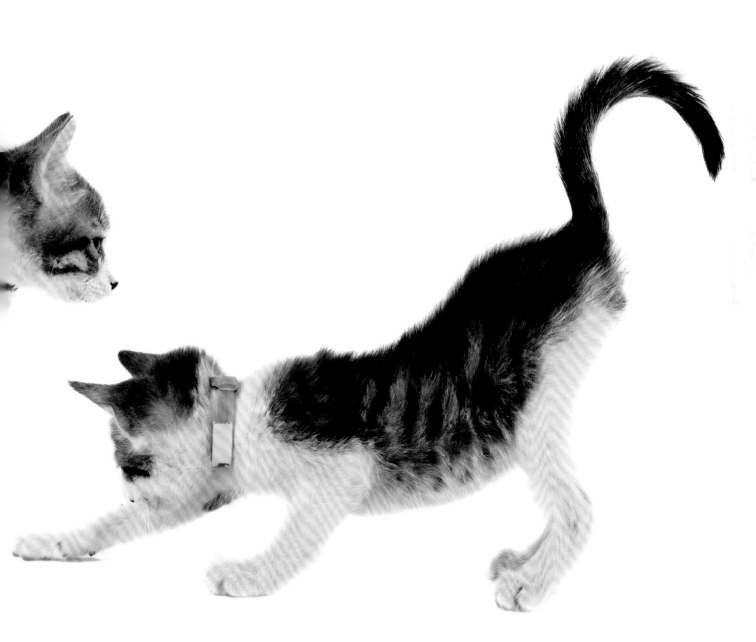

Kitten

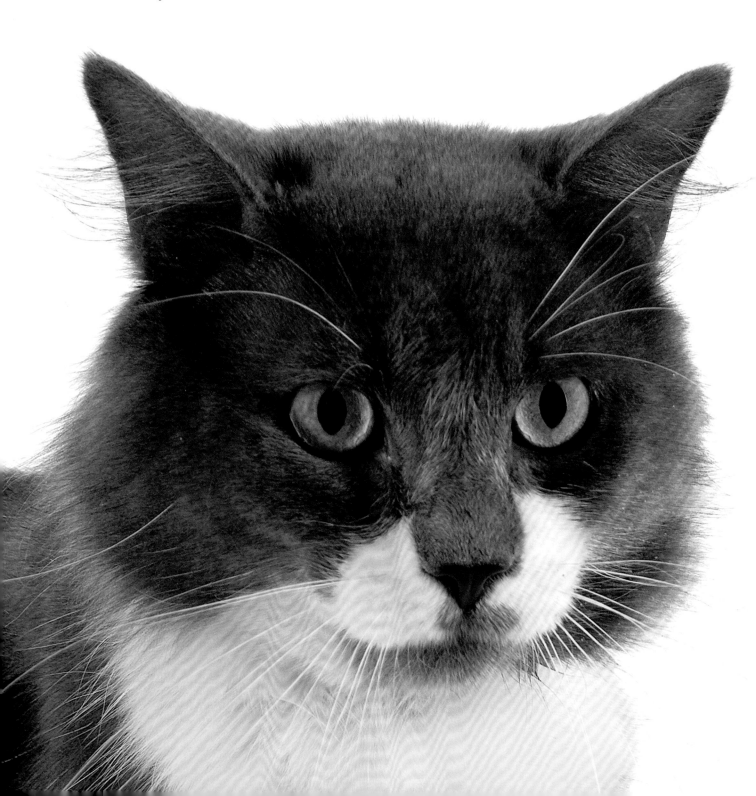

Rocky

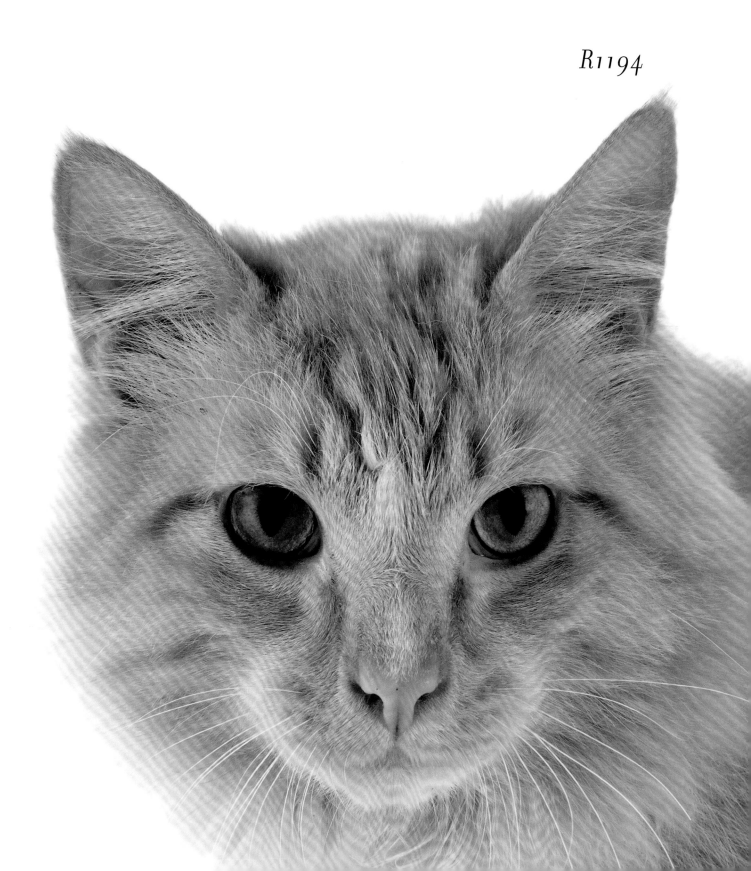
R1194

Precious

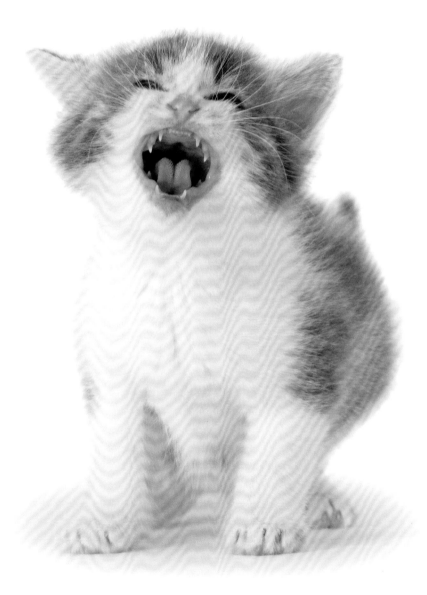

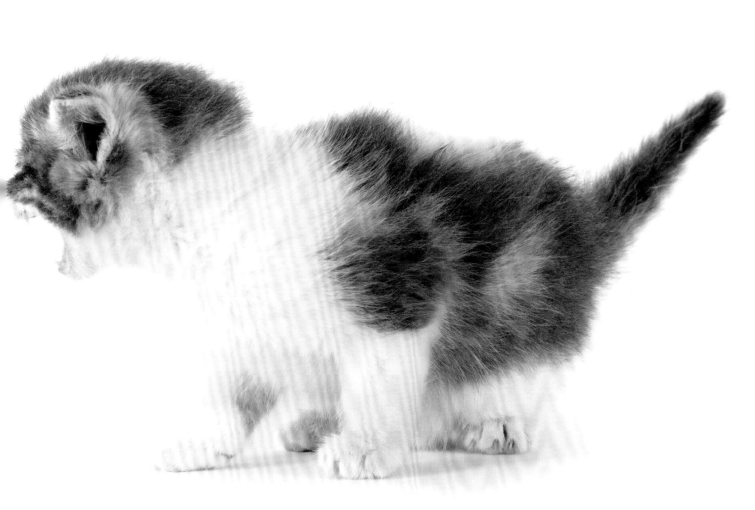

Julius

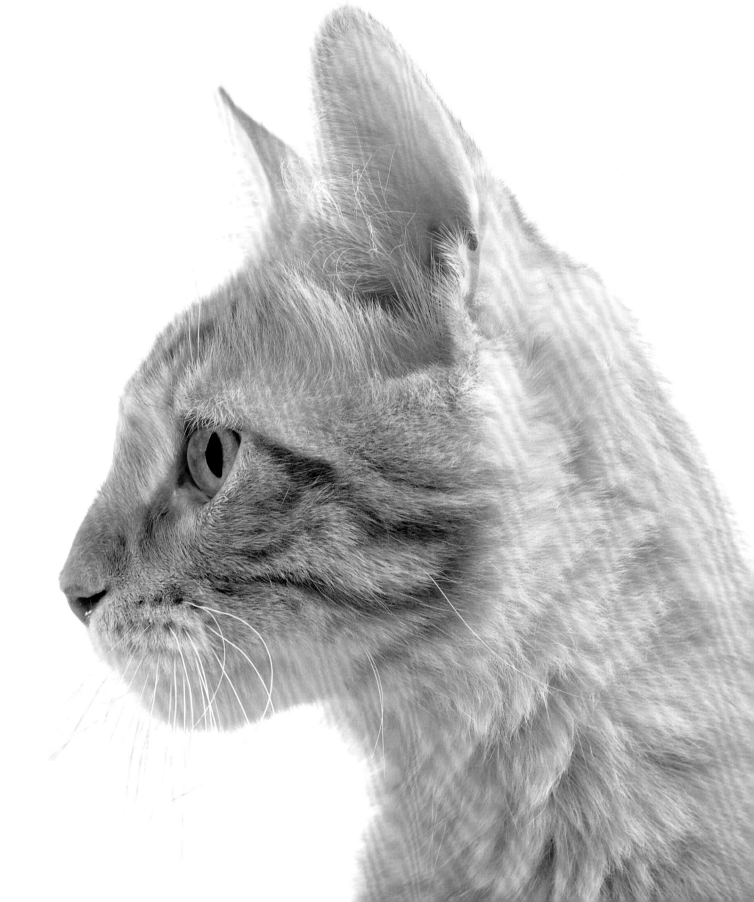

P1835

Kitten P1835 was very eager to get my attention, and reached out between the bars of her cage to touch me while I was recording her information. She didn't mind my camera, but preferred that I used our session to pet her and scratch her ears. Each time I stopped, she made a running leap for the edge of the table.

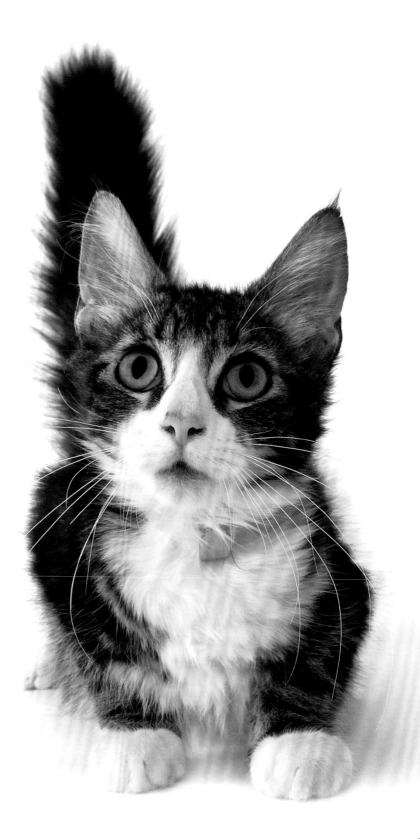

Noble

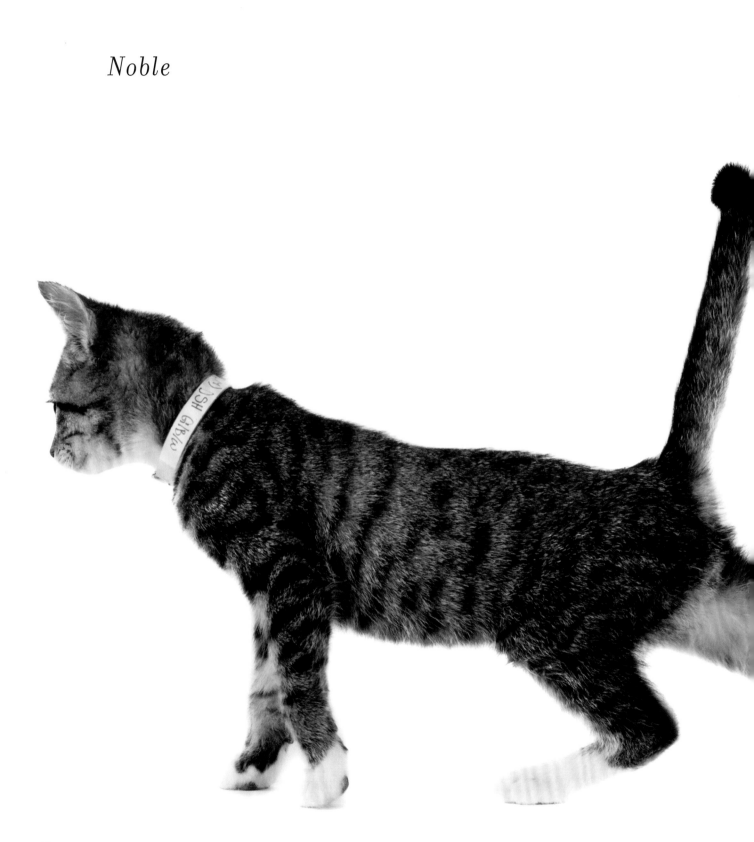

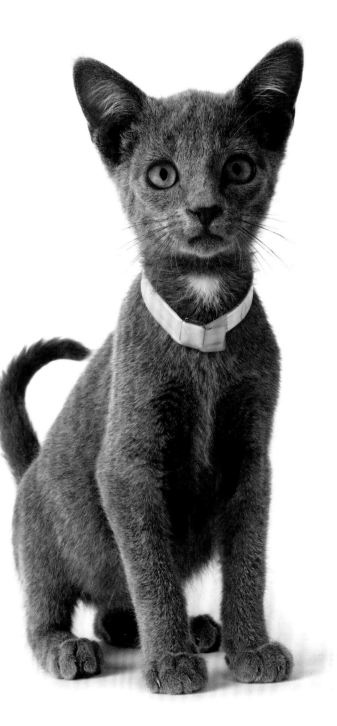

Sammy

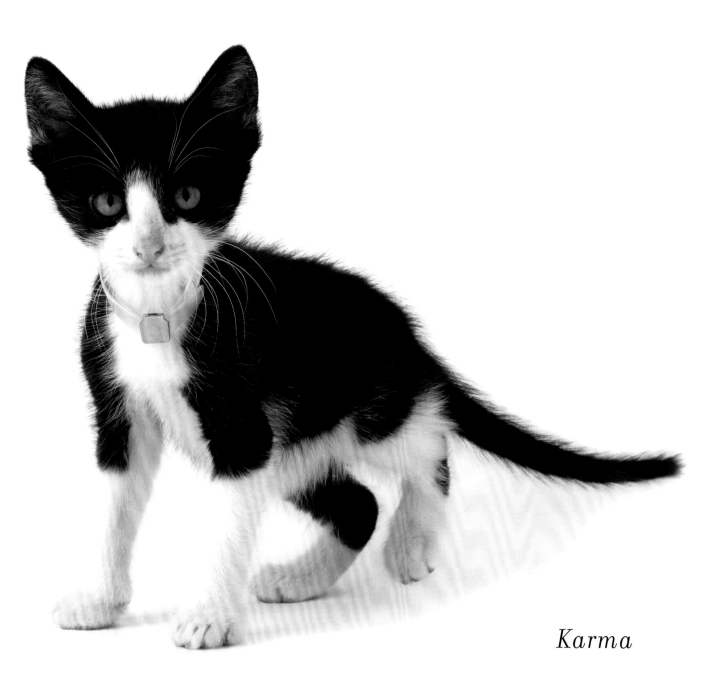

Karma

Peach

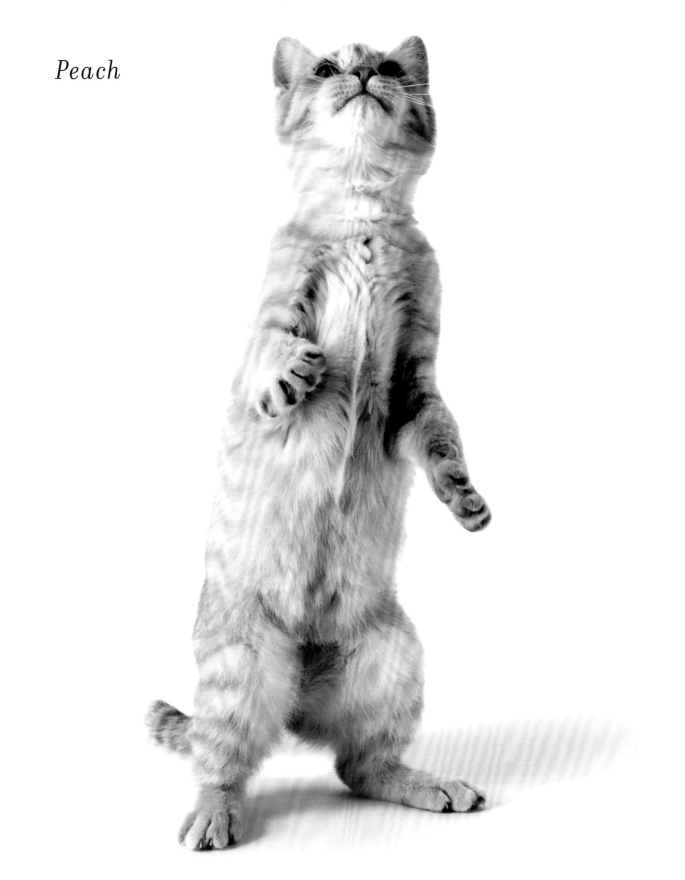

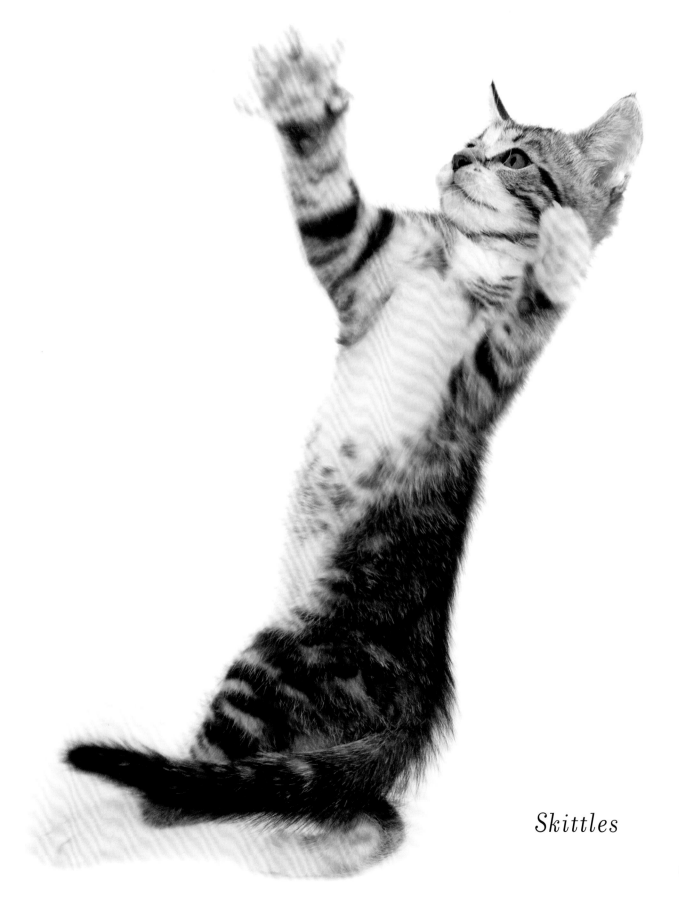

Skittles

P1834

*I was so taken by Egyptian mau P1834 that
I photographed her twice over the course of her
forty-two-day stay at the Tri-Cities Animal Shelter.
There was an intensity in her gaze, and she had
exceptionally striking features. I was surprised when
she was not adopted quickly, and was very sad
when I learned that she became ill.*

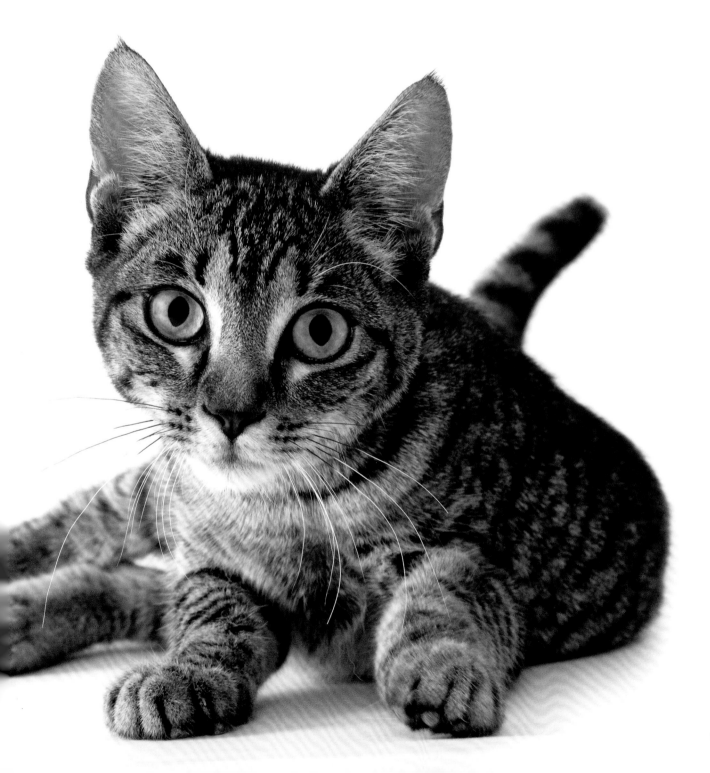

Kimba

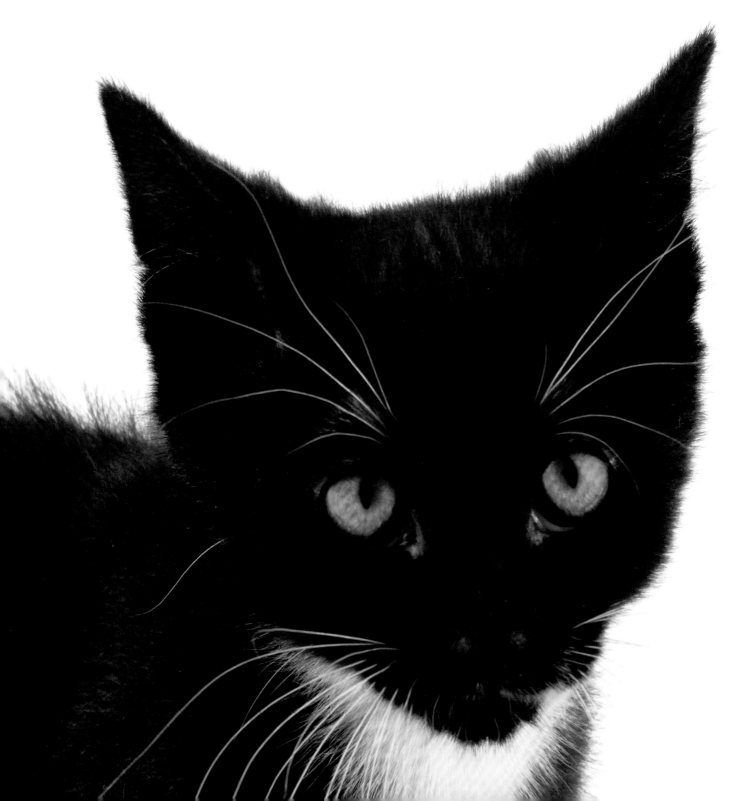

Sasha

Bucket

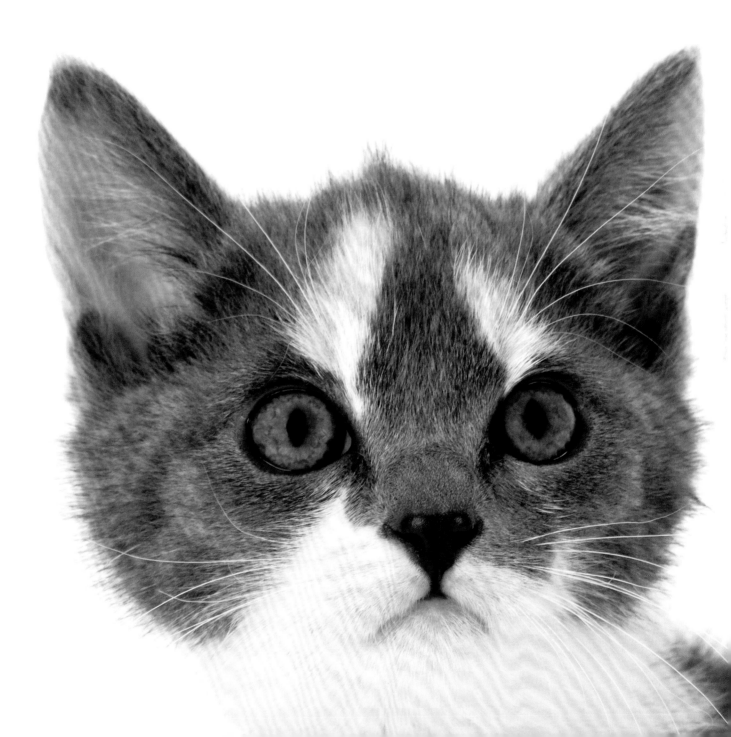

Hope

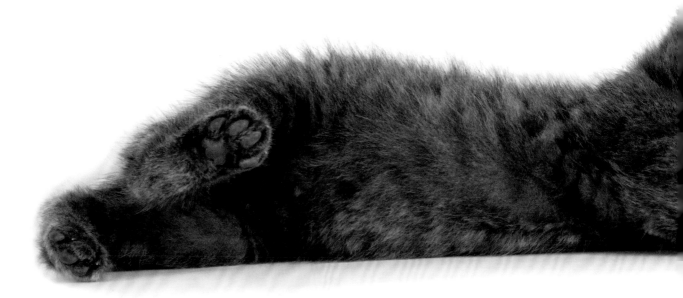

Kitten

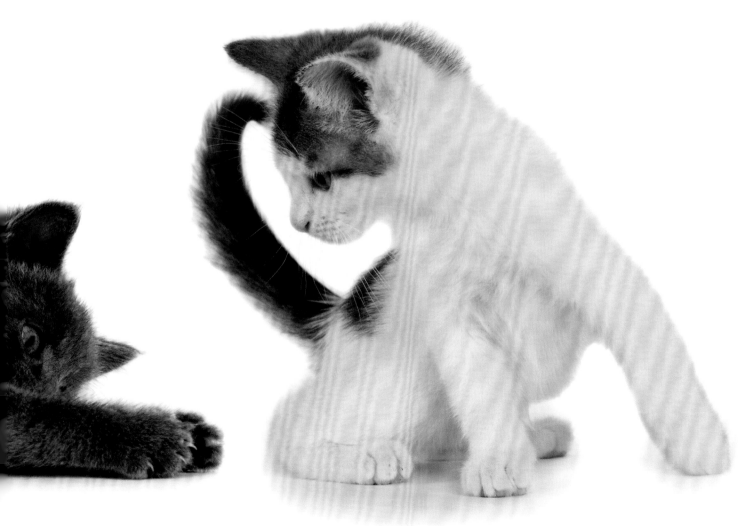

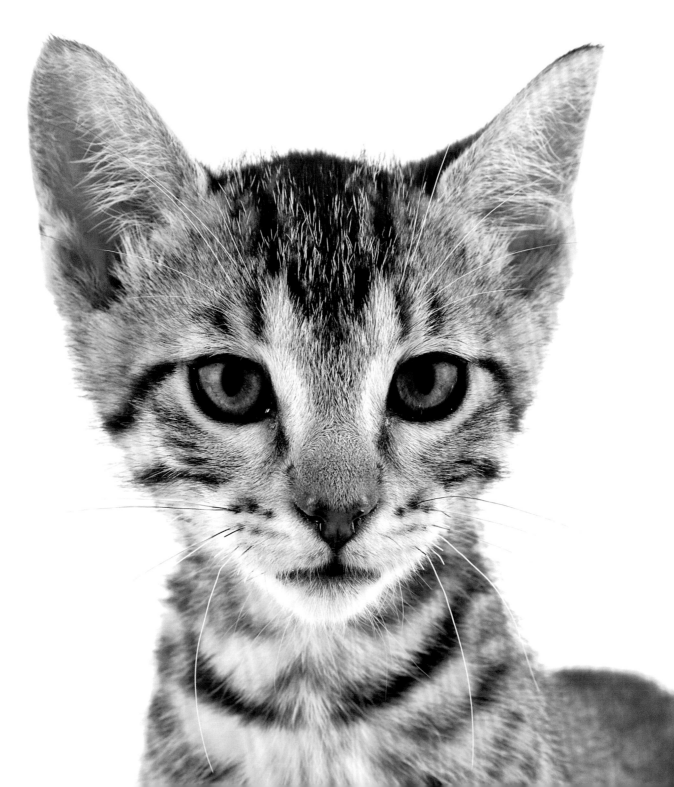

Kitten

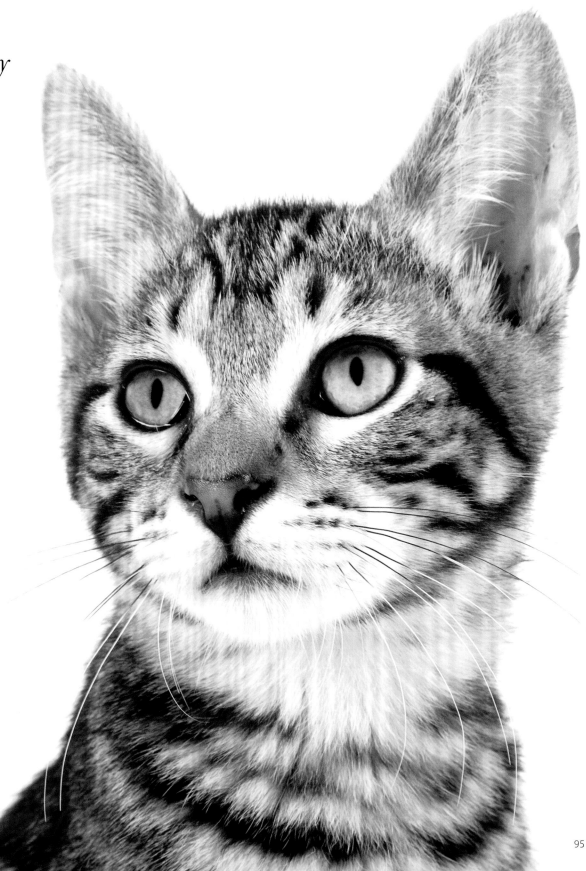

Andy

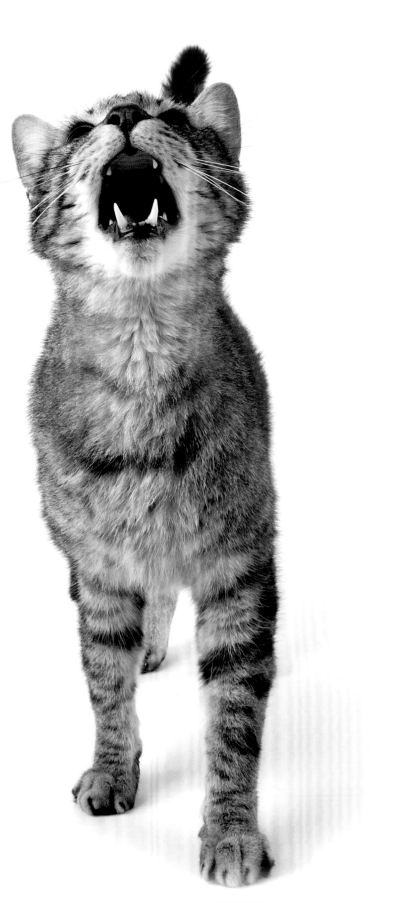

Sonia

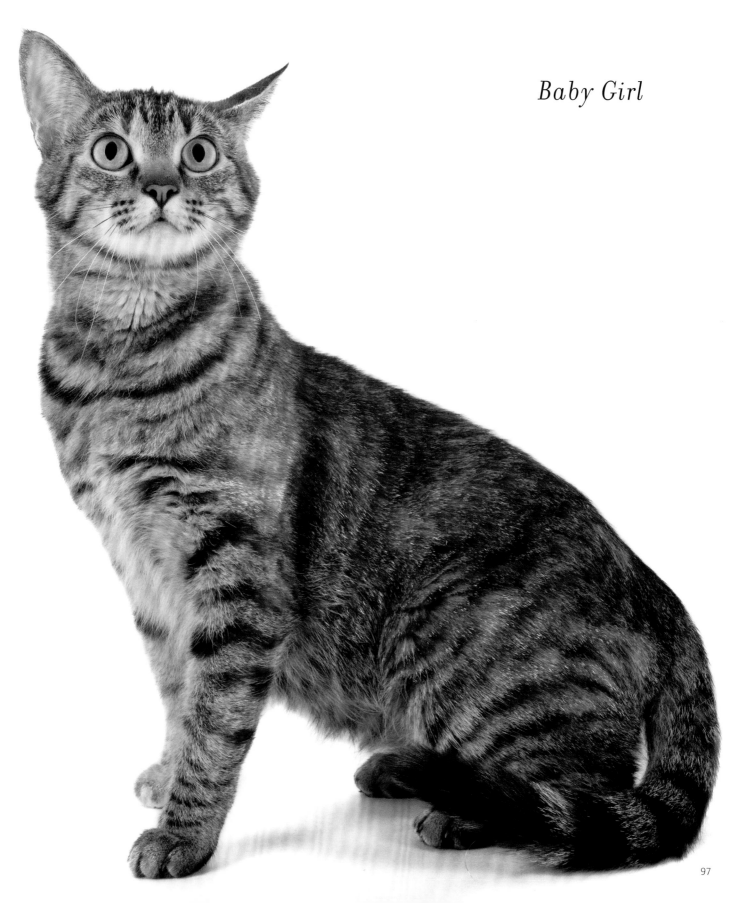

Baby Girl

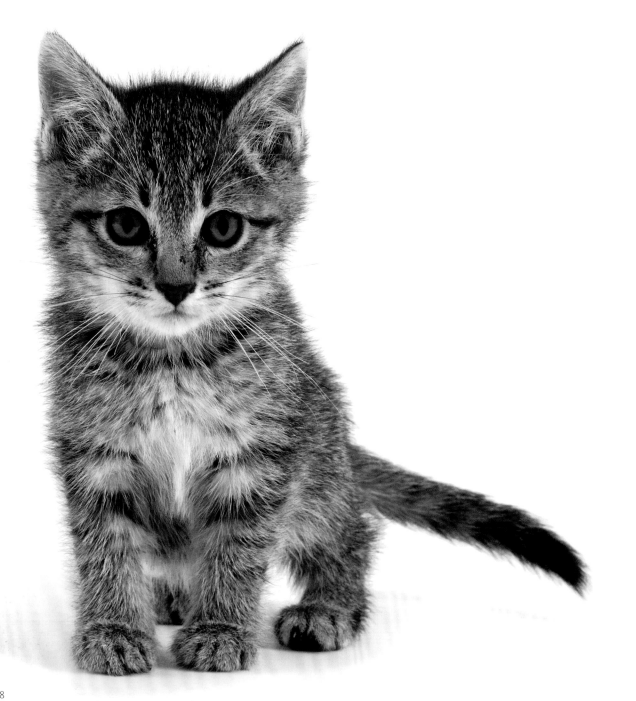

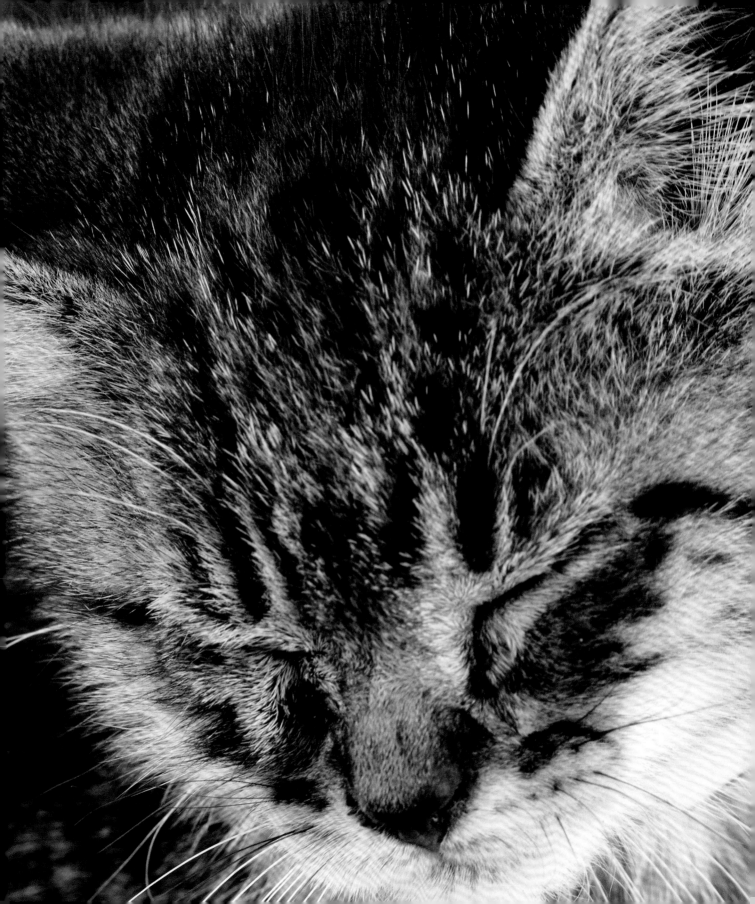

Kitten

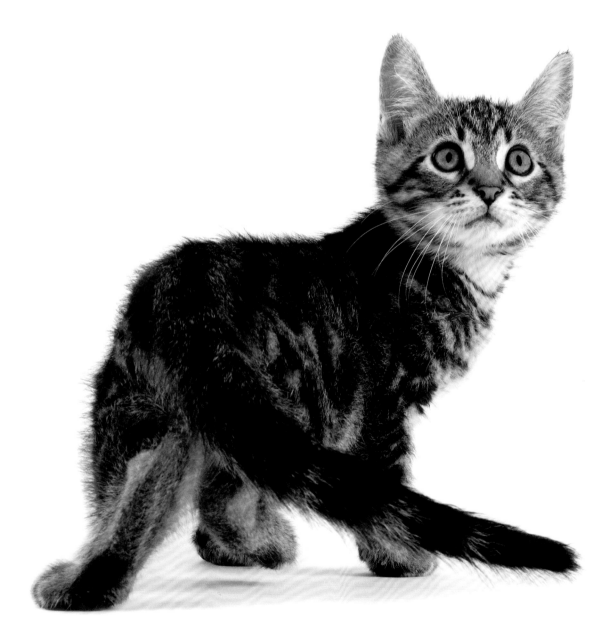

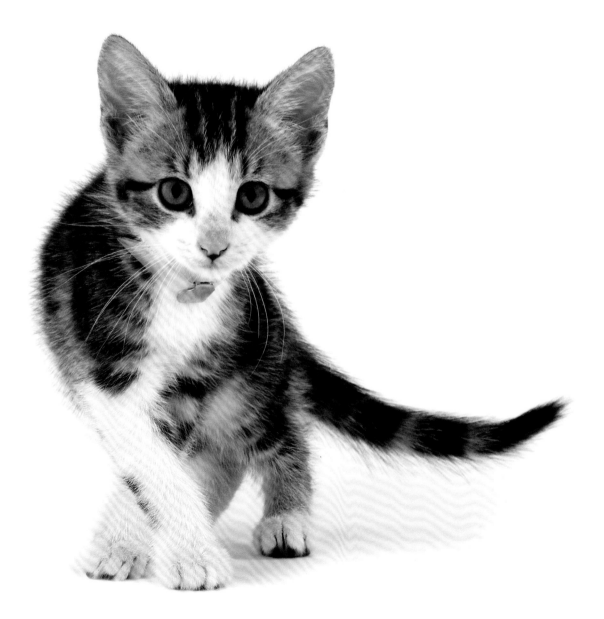

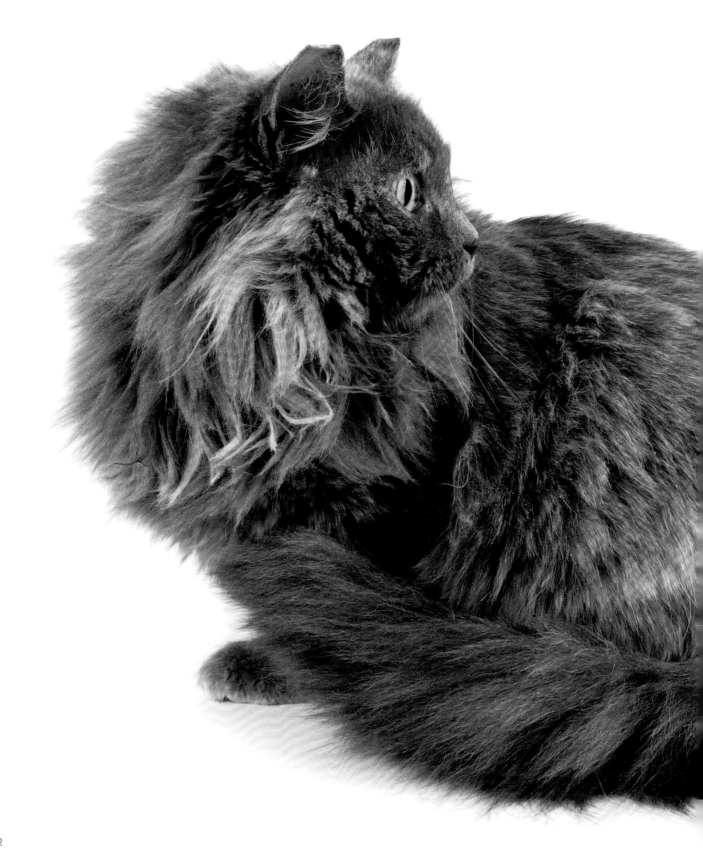

Charlotte

*Charlotte was one of the few cats that
I photographed outside of the shelter. It was
evident from the start that traveling with the
cats before our session served only to make
them nervous. While this might seem obvious
to some people, I'd been photographing
mostly dogs until this point, and they often
do better once they are removed from the
commotion of the shelter.*

Captain Hook

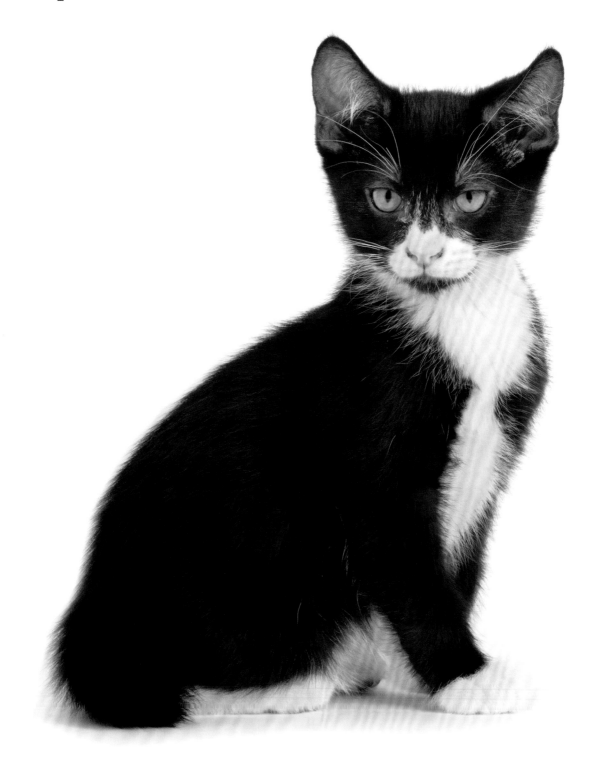

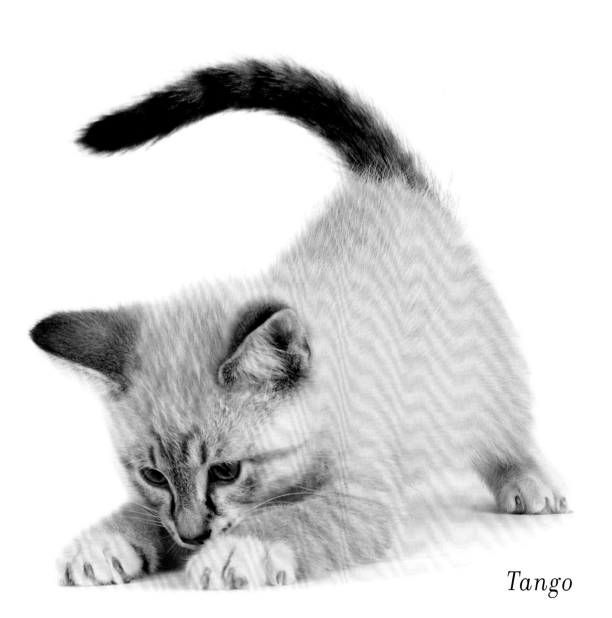

Tango

Sybil

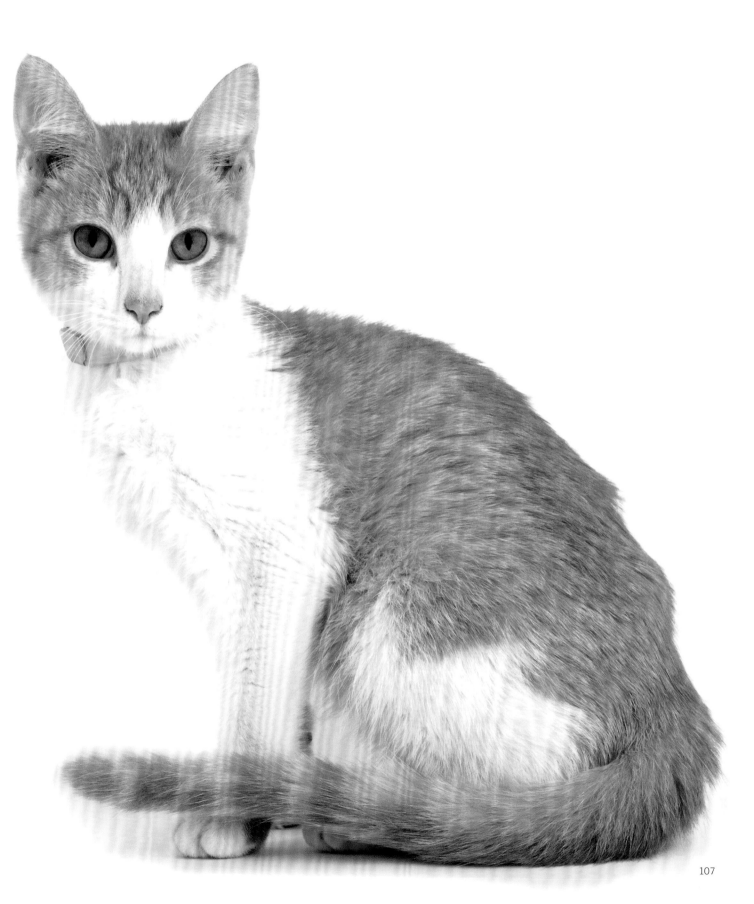

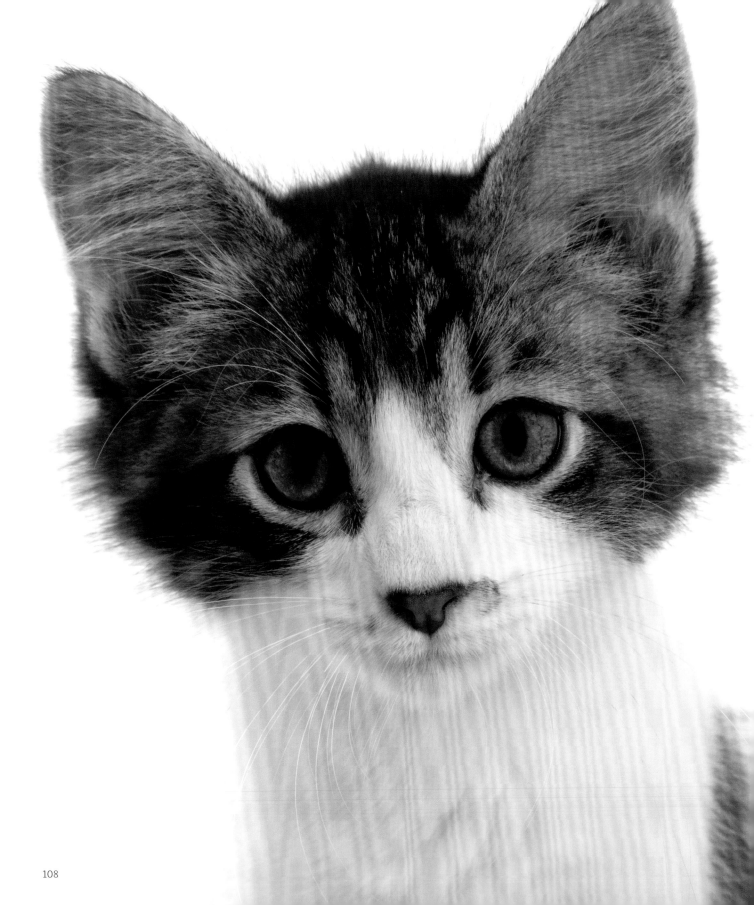

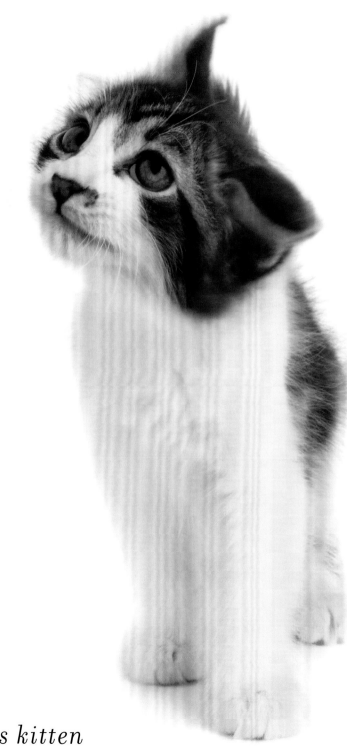

Cindy's kitten

Radar

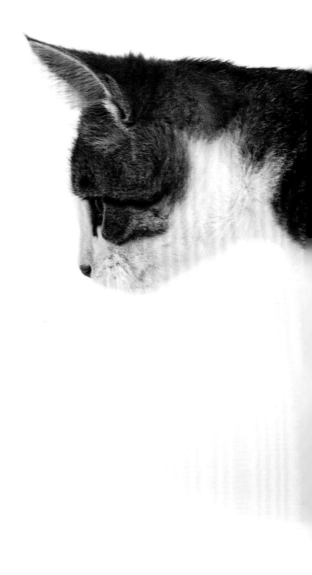

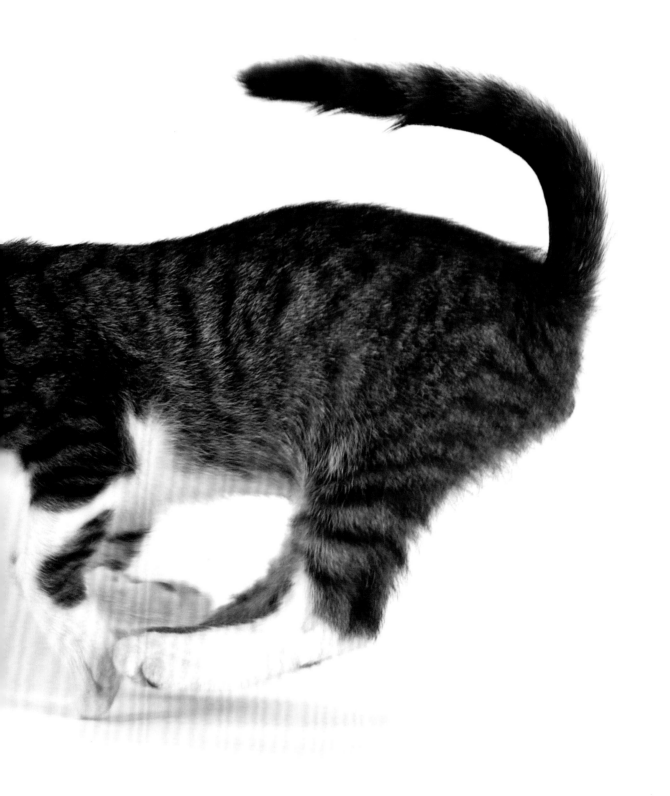

Scotty

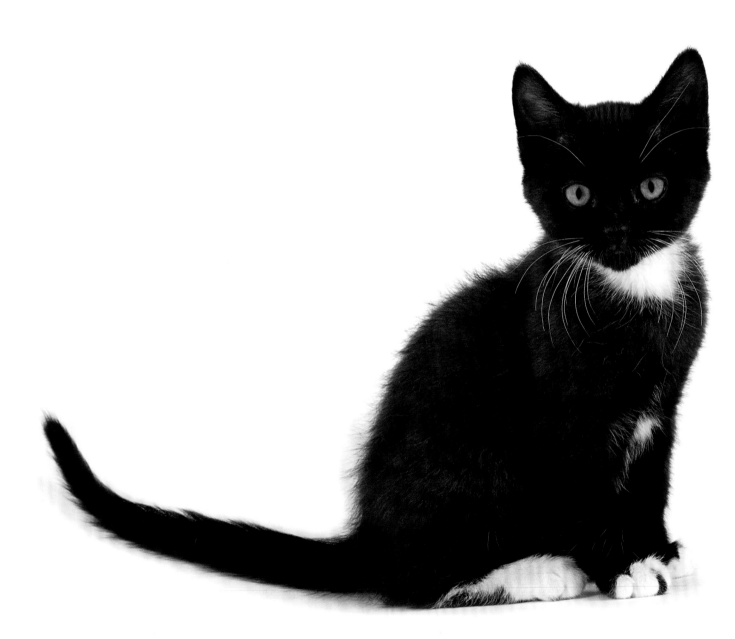

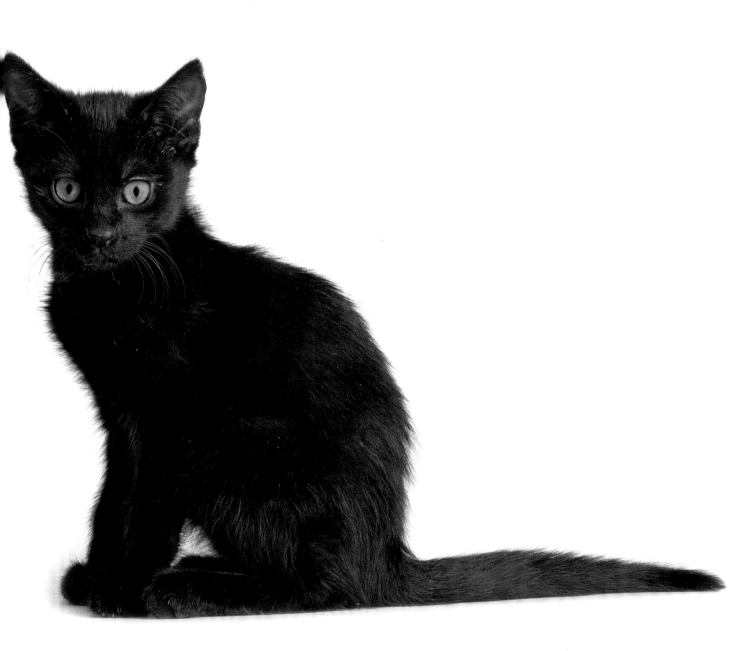

Suey

Sasquatch

It was love at first sight, but, with five other cats at home, it wasn't going to happen. That changed a few months later, when we met again unexpectedly and the same feeling was there. The young cat called Little Magic had a home and a name change. His freakishly large paws earned him the name Sasquatch, which is more appropriate for a cat who's now 16 lb. He continues to be the same goofy and loving character that made him stand out from the rest; there's just more of him to love!

Aaron Mortensen and Monica Bauman,
Sasquatch's owners

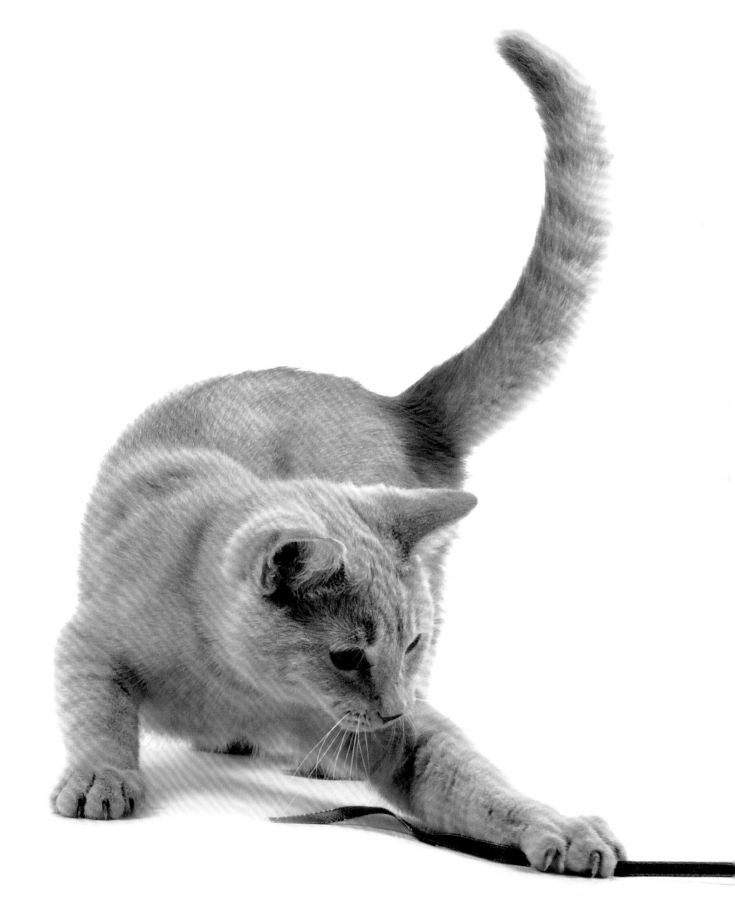

Kitten

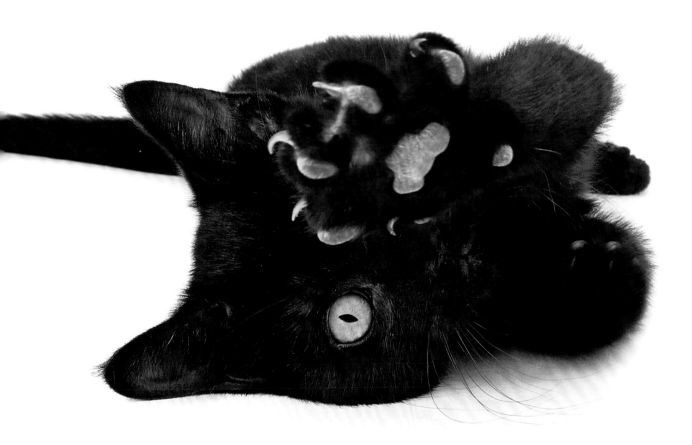

Who's who

These biographies are based on information provided by the various animal shelters. Different shelters record different information on the cats in their care, and some shelters do not give a name to each cat or kitten prior to adoption.

PAGE 1: *Socks*
Three-year-old black-and-white Socks had been waiting for a home for 131 days when I photographed him.

PAGES 2 & 19: *Mulan*
Three-year-old Persian mix Mulan was surrendered to the Benton-Franklin Humane Society rail-thin and with her fur so badly matted that most of her hip had to be shaved. The BFHS determined that she'd need to gain some weight before she'd be available for adoption, and she immediately went into foster care with a family interested in adopting her. It was love at first sight, and she was adopted after twelve days.

PAGES 4–5: *Tiger*
One-year-old Tiger was one of my more camera-shy subjects. He was always on the move, so his graceful nature was easy to capture. He was adopted after ten days.

PAGE 16: *Sophie*
Sophie was about one year old when she was brought to the Tri-Cities Animal Shelter with her litter of six kittens (two of them are on the front of the jacket). She became very ill and died twenty days later.

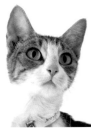

SEE PAGE 2

PAGE 20: *Misha*
One-and-a-half-year-old Russian blue/domestic shorthair mix Misha was brought to the BFHS when she was pregnant, and was immediately put into a foster home. She was adopted about a month after her kittens were weaned (see page 113).

PAGE 21: *Black Jack*
Curious and amiable, three-month-old Black Jack was surrendered to the BFHS with his sister. He was adopted a week later.

PAGE 22: *Trigger*
Domestic medium hair Trigger was one and a half years old when she was brought to the Tri-Cities Animal Shelter. She was adopted after 119 days.

PAGE 23: *Vegas*
A playful cat, Vegas was very eager to be the center of attention. He was adopted after 185 days.

PAGES 24–25: *Miss Kitty*
Miss Kitty spent 612 days at the Woodford Humane Society before being adopted in January 2009. She was returned four months later and was still waiting for a new home at the time of writing.

PAGES 26 & 52–53: *Kittens*
Brought to the BFHS with their mother and three littermates, these kittens were immediately placed in foster care. Once they were old enough to be on their own, they were put up for adoption. They were adopted after waiting between two weeks and three months.

PAGE 27: *P2084*
Eight-week-old domestic medium-hair kitten P2084 was napping with his brother when I came to photograph them. They were transferred to a rescue group with their sister after seven days.

PAGES 28–29: *Little Bug*
An incredibly active girl, Little Bug spent the entire ten-minute photographic session playing and stretching. She was adopted after nine days.

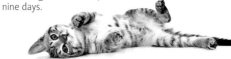

PAGE 31: *Ozzy*
I photographed Ozzy twice during his stay at the BFHS. We sometimes do a second session with a cat after a few months, because it's one of the few opportunities the cats have to get out, stretch their legs, and play for a while. Ozzy was adopted shortly after celebrating his first anniversary at the humane society; he lived there for a total of 390 days before finding a home.

PAGE 32: *Olivia*
Olivia was adopted after several months at the Woodford Humane Society, but was soon returned after her new owners discovered she had a serious health problem. Olivia was euthanized.

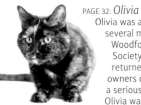

PAGE 33: *R3002*
Calico domestic shorthair R3002 spent twenty-six days at the Tri-Cities Animal Shelter. She became ill with an infection and was euthanized.

PAGE 39: *Casey*
Domestic shorthair Casey arrived at the Tri-Cities Animal Shelter at two months old. He contracted an infection and was euthanized after twenty-eight days.

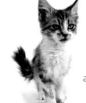

PAGE 44: *Kitten*
This kitten was one of two ten-week-old littermates surrendered to the BFHS with fleas. Very playful and affectionate after their treatment, they were both adopted within two weeks.

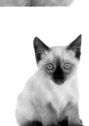

PAGES 34, 90, & 112: *Sulu, Sasha, & Scotty*
Eight-week-old littermates Sulu, Sasha, and Scotty were surrendered to the BFHS as soon as they were old enough to be apart from their mother. Sulu's striking blue eyes helped him find a home seven days after his arrival. Sasha and Scotty were adopted after twenty-three days.

PAGE 40: *Scarlet*
Domestic longhair Scarlet was about two years old when she was brought to the BFHS. She was adopted after 106 days.

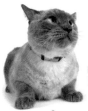

PAGE 45: *Charlotte*
Domestic medium hair Charlotte was dropped off at the BFHS as an adult. Her friendly personality helped her find a home forty-two days after her arrival.

PAGES 35 & 104:
Puma's kitten & Captain Hook
These eight-week-old kittens, from a litter of six, were born in foster care after their mother, Puma, was surrendered to the BFHS. All the kittens were adopted quickly except for Captain Hook, who was still waiting for a home two months later.

PAGE 41: *Clara*
Playful young adult tabby Clara was surrendered to the BFHS and adopted after ten days.

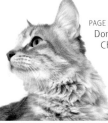

PAGE 46: *Billy*
Six-year-old Siamese Billy was adopted shortly after my session with him, but returned to the BFHS nine months later, quite a bit heavier. He found a new home after twenty-eight days.

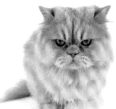

PAGES 36–37: *Binks*
Two-year-old Persian Binks was abandoned at the BFHS after his owner refused to fill out a surrender form. He was adopted after eight days.

PAGES 42 & 100: *Kittens*
These nine-week-old tabbies were brought to the BFHS with their littermates. They were adopted between two and four weeks after their arrival.

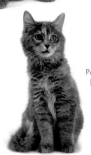

PAGES 48 & 49: *Asparagus*
Domestic longhair Asparagus was a very curious cat. He was adopted after 107 days.

PAGES 38 & 91: *Bucket*
Bucket was eight weeks old when he was surrendered to the BFHS. He was placed in foster care until he was old enough to be on his own, and was adopted after forty-eight days.

PAGES 43, 60, & 61:
Kittens
These ten-week-old kittens were surrendered to the BFHS together. All kittens in the litter were adopted within two months.

PAGES 50 & 51: *Finnegan*
Finnegan was brought to the Tri-Cities Animal Shelter at one week old with his mother and four littermates. His future owners met him before he was old enough to be adopted. Although the shelter prefers to keep kittens with their mother until they are ten weeks old, it will allow kittens to be adopted as soon as they receive their first round of shots. Finnegan was adopted at seven weeks old, after forty-one days at the shelter.

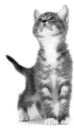

SEE PAGE 26

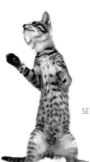

SEE PAGE 43

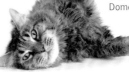

PAGES 68–69: *Wyatt*
Domestic longhair Wyatt, later shortened to Wy when the staff at the Tri-Cities Animal Shelter realized she was female, was very friendly. She was adopted after 143 days.

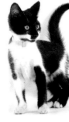

PAGE 54: *King*
King was four months old when he was brought to the Tri-Cities Animal Shelter. He was euthanized ten days later, after suffering an infection.

PAGE 63: *Pumpkin*
Surrendered to the BFHS completely declawed, overweight, and with badly matted fur, four-and-a-half-year-old Maine coon/domestic longhair mix Pumpkin was given a "lion cut" by the groomer. He spent two weeks in foster care before being put up for adoption, and was then adopted after twenty-two days.

PAGES 70–71: *Kitten*
This eight-week-old domestic medium-hair kitten was in a cage with her two brothers. All three kittens were sleeping soundly when I took them for their session, and I began with the males. Undisturbed, this kitten slept through each cage opening, and opened her eyes only when I picked her up to bring her to my studio. She and her brothers were transferred to a rescue group after seven days at the Tri-Cities Animal Shelter.

PAGES 55 & 56–57:
Manga's kittens
These eight-week-old kittens were surrendered with their mother, Manga, and their four littermates. The first kitten was adopted after thirty days, while the last waited seventy-two days for a new home.

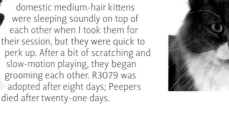

PAGES 64–65: *R3079 & Peepers*
These six-week-old black domestic medium-hair kittens were sleeping soundly on top of each other when I took them for their session, but they were quick to perk up. After a bit of scratching and slow-motion playing, they began grooming each other. R3079 was adopted after eight days; Peepers died after twenty-one days.

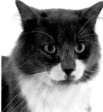

PAGE 72: *Rocky*
Gray-and-white domestic medium-hair Rocky was about one year old when Animal Control brought him to the Tri-Cities Animal Shelter. He was still available for adoption after 199 days.

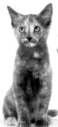

PAGE 58: *Rocket*
Four-month-old domestic medium hair Rocket was brought to the Tri-Cities Animal Shelter when he was two months old. He was adopted after seventy-seven days.

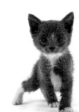

PAGE 66: *Soda*
Gray-and-white domestic shorthair Soda was just one week old when he was brought to the Tri-Cities Animal Shelter with his mother and littermates. He was still waiting to be adopted after ninety days.

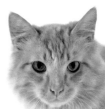

PAGE 73: *R1194*
Staff at the Tri-Cities Animal Shelter advertised this one-and-a-half-year-old domestic shorthair male as very sweet and affectionate. He was adopted after seventy days.

PAGE 59: *Garfield*
Ten-month-old domestic shorthair Garfield was a sweet cat who grew up with other cats, dogs, birds, guinea pigs, and children; this typically makes it easy to find a new home. He was adopted after twenty-five days.

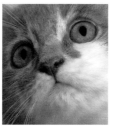

PAGE 67: *Mary Anne*
Mary Anne was surrendered to the BFHS with four littermates. All the kittens were adopted within a month.

PAGES 74 & 75: *Precious*
Precious was brought to the BFHS with her littermates. While her siblings were adopted quickly, she had to wait almost three months before finding a home.

PAGE 77: *Julius*
Domestic shorthair Julius was about one year old when he was surrendered to the BFHS. He was adopted after sixty-one days.

PAGE 84: *Peach*
Domestic shorthair kitten Peach was very active and playful while living at the BFHS. She was adopted after sixty-three days.

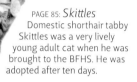

SEE PAGE 38

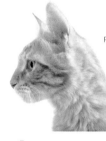

PAGE 79: *P1835*
Domestic medium-hair kitten P1835 was five months old when she was brought to the Tri-Cities Animal Shelter. She contracted an infection and was euthanized after twenty-eight days.

PAGE 85: *Skittles*
Domestic shorthair tabby Skittles was a very lively young adult cat when he was brought to the BFHS. He was adopted after ten days.

PAGES 92–93: *Hope*
Hope arrived at the BFHS with her mother and a litter of siblings. She was euthanized after succumbing to the feline leukemia virus.

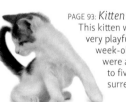

PAGES 80–81: *Noble*
Domestic shorthair Noble was four months old when he was brought to the Tri-Cities Animal Shelter. He was still waiting to be adopted after seventy-six days.

PAGES 86–87: *P1834*
This four-month-old Egyptian mau was not given a name during her forty-two days at the Tri-Cities Animal Shelter. She contracted an infection and was euthanized.

PAGE 93: *Kitten*
This kitten was one of a group of very playful and energetic eight-week-old littermates who were all adopted within one to five weeks of being surrendered to the BFHS.

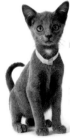

PAGE 82: *Sammy*
Four-month-old domestic shorthair Sammy was very curious about me as I prepared to photograph him. He was adopted after thirteen days.

PAGES 88–89: *Kimba*
Black, tan, and gray domestic shorthair Kimba was seven weeks old when he arrived at the Tri-Cities Animal Shelter. He became ill with an infection and was euthanized fourteen days later.

PAGE 94: *Kitten*
This domestic shorthair kitten was brought to the BFHS as one of a litter of four. All the kittens were adopted within three weeks.

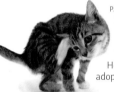

PAGE 83: *Karma*
Seven-week-old black-and-white domestic shorthair Karma was brought to the Tri-Cities Animal Shelter with his five littermates. He was euthanized ten days later, after suffering an infection.

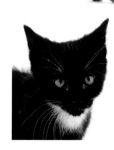

SEE PAGE 34

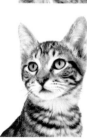

PAGE 95: *Andy*
Domestic shorthair Andy was surrendered to the BFHS with his brother when they were about four months old. Andy was adopted twelve days later.

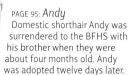

121

PAGE 96: *Sonia*
A two-year-old domestic shorthair, Sonia was a talker. When I photographed her, it was difficult to capture her with her mouth closed. She contracted an infection and was euthanized after twenty-eight days.

PAGE 101: *Kahula*
Kahula was seven weeks old when she was brought to the Tri-Cities Animal Shelter with her littermates. She became ill and died nine days later.

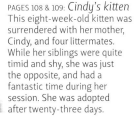

PAGES 108 & 109: *Cindy's kitten*
This eight-week-old kitten was surrendered with her mother, Cindy, and four littermates. While her siblings were quite timid and shy, she was just the opposite, and had a fantastic time during her session. She was adopted after twenty-three days.

PAGE 97: *Baby Girl*
Domestic shorthair tabby Baby Girl was one and a half years old when she was surrendered to the BFHS. She was adopted six weeks later.

PAGES 102–103: *Charlotte*
With long hair, dilute tortoiseshell markings, and clipped ears, Charlotte was striking, but her timid nature resulted in a long tenure at the Woodford Humane Society. She was adopted after 172 days.

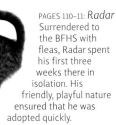

PAGES 110–11: *Radar*
Surrendered to the BFHS with fleas, Radar spent his first three weeks there in isolation. His friendly, playful nature ensured that he was adopted quickly.

PAGE 98: *P2069*
The information card for this seven-week-old domestic medium-hair kitten said that she was scared; however, she seemed sure of herself during her session. She was adopted after nine days.

SEE PAGE 35

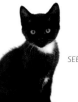

SEE PAGE 34

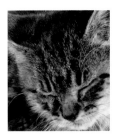

PAGE 99: *P2079*
Five-week-old domestic medium-hair kitten P2079 was sleeping soundly when I picked him up for his session. Although it isn't obvious from this portrait, he was lively and inquisitive while being photographed. He was transferred to a rescue group after seven days.

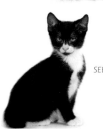

PAGE 105: *Tango*
Tango arrived at the BFHS with his mother and five siblings. He was adopted after a nine-day stay by a family living more than 120 miles (193 km) away, who saw his photograph on Petfinder.com.

PAGE 113: *Suey*
Suey was born in foster care after her mother, Misha (see page 20), was surrendered to the BFHS. She was put up for adoption at eight weeks old, and was adopted four weeks later.

SEE PAGE 42

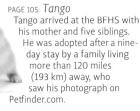

PAGE 107: *Sybil*
Orange-and-white domestic shorthair Sybil was four months old when she was brought to the Tri-Cities Animal Shelter. She was adopted two weeks later.

PAGE 115: *Sasquatch*
Sasquatch spent most of his first year at the Woodford Humane Society after arriving as a kitten. He was adopted after 213 days.

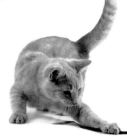

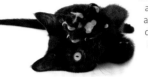

PAGES 116–17: *Kitten*
This eight-week-old kitten made the most of his time out of his crate, and spent the entire session stretching and playing. He was adopted later that same day, after thirty-five days at the BFHS.

PAGE 128: *Kitten*
This seven-week-old kitten was photographed about a week before becoming eligible for adoption. This kitten and its three siblings were adopted after less than three weeks at the BFHS.

FRONT OF JACKET:
K3112 & K3116 (Willie)
Brothers K3112 (on the left) and K3116 (later named Willie) were both brought to the Tri-Cities Animal Shelter with their mother, Sophie (see page 16), and other littermates when they were eight weeks old. K3112 was adopted after a week; Willie was adopted after twenty-one days.

Photographing cats

There are many ways to help your local cat shelter. One of them is to photograph the adoptable cats and kittens. If this book has inspired you, I've put together a series of tips to get you started.

• Safety is the most important consideration. Always work in a room with closed doors in order to ensure that your feline subject can't escape.

• Photograph in a room with plenty of light.

• It helps to use an SLR camera with studio lighting, but it's not essential. If you have a slower point-and-shoot digital camera and are having difficulty keeping your cat in the frame, try shooting in continuous mode.

• Consider working with a partner. With two people in the room, one person can focus on playing with and posing the cat, while the other concentrates on creating the image.

• Eliminate as much clutter as possible from the frame. If possible, use a background (even an old sheet will do), so there's nothing in the picture to compete with your subject for the viewer's attention.

• Treats often work well if you're photographing a dog, but they rarely help in securing a cat's attention. Catnip is an especially poor choice, because it makes many cats very "squirrelly."

• Toys may or may not help you get the right image. If the cat is initially uninterested in playing with your toy, then you might as well put it away.

• It's helpful to use a table for your sessions. Not only will it be easier for you to move with the cat, but also it'll help you capture nice photographs of her face, because it's easier to hold your camera at her level.

• Pay attention to your cat's body language. If your subject is playful, you can capture some wonderful poses that highlight her personality. If your cat is afraid, you probably won't be able to win her over during a brief session, but you might be able to make the best of it with a quick face shot.

• Above all, enjoy playing with the cat. Even if you don't come away with a great picture of your subject, the cat will benefit from some attention and fun exercise.

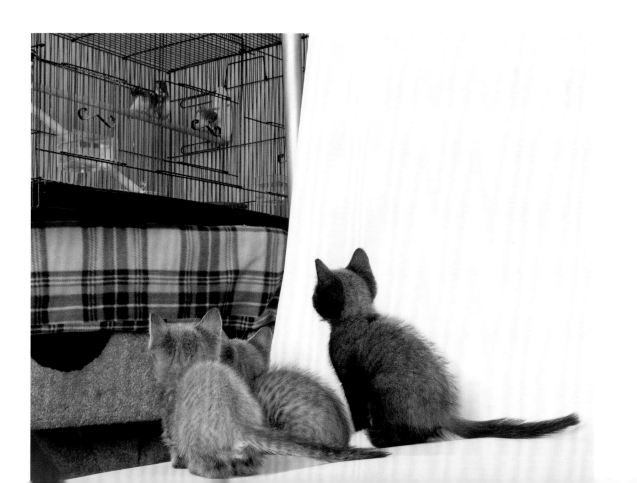

Facts and figures

• An estimated three to four million cats and dogs are euthanized every year in the United States.

• 33 percent of US households own at least one cat, and 39 percent own at least one dog.

• In theory, a pregnant cat and her offspring can produce 420,000 cats over the course of seven years.

• Realistically, without any human intervention, an unaltered cat and her offspring can produce about 3200 cats over twelve years.

• The average life span of an outdoor-only cat is three years. Indoor cats have been known to live for more than thirty years.

• About 20 percent of the estimated 90 million-plus cats in US homes were adopted from animal shelters.

• Less than 5 percent of lost cats brought to shelters are reclaimed by their owners.

• While the number of cat adoptions is increasing, so is the rate of feline euthanasia.

• Approximately $2 billion of US taxpayers' money is spent each year capturing, caring for, euthanizing, and disposing of homeless animals.

Sources: The Humane Society of the United States; American Pet Products Association, 2009–2010 National Pet Owners Survey; Feral Cat Coalition; National Pet Alliance; "Cat Facts and Trivia," CatStuff (http://xmission.com/~emailbox/trivia.htm); *Journal of the American Veterinary Medical Association*; Change.org

Charitable organizations

The cats featured in this book were all photographed while they were waiting for their "forever homes" and, in most cases, were photographed at the animal shelter or humane society providing their care. For more information about these facilities, visit their websites:

Benton-Franklin Humane Society
bfhs.com

Tri-Cities Animal Shelter
tri-citiesanimalshelter.com

Woodford Humane Society
woodfordhumanesociety.org

UNITED STATES

The American Society for the Prevention of Cruelty to Animals (ASPCA)
aspca.org

Founded in 1866, the ASPCA was established with the goal of creating legal protection for animals. Today, it provides local and national leadership on animal welfare issues, with the support of more than one million people across the United States.

The Humane Society of the United States (HSUS)
humanesociety.org

Established in 1954, the HSUS is the nation's largest animal protection agency. It seeks to better the lives of all animals through legislation, education, investigation, advocacy, and fieldwork.

Alley Cat Allies
alleycat.org

Founded in 1990 to lead the movement for the humane care of cats, Alley Cat Allies introduced the practice of spaying and neutering entire colonies of stray and feral cats across the United States through

its trap-neuter-return programs, and continues to educate the public on all issues related to cat welfare.

Best Friends Animal Society

bestfriends.org

Established in 1991, Best Friends Animal Society promotes the philosophy that "kindness to animals builds a better world for all of us." It runs the nation's largest animal sanctuary, and campaigns to end the killing of homeless animals in shelters.

PetSmart Charities

petsmartcharities.org

Founded in 1994, PetSmart Charities operates Adoption Centers in all PetSmart stores across the United States and Canada, where local animal welfare agencies can find new homes for adoptable animals. PetSmart Charities has donated over $100 million to animal programs in North America while helping to save more than four million pets.

AUSTRALIA

RSPCA Australia

rspca.org.au

Established in 1980, the RSPCA is the leading authority in animal care and protection in Australia. Its shelters across the country receive more than 144,000 animals every year.

CANADA

Canadian Federation of Humane Societies (CFHS)

cfhs.ca

Established in 1957, CFHS serves as the national voice of animal welfare organizations across Canada. It promotes the humane treatment of all animals, and champions legislation that improves animal protection and aims to end cruelty.

Canadian Society for the Prevention of Cruelty to Animals (CSPCA)

spcamontreal.com

Established in 1869, the CSPCA is the oldest humane society in Canada. Its mission is to protect animals against negligence, abuse, and exploitation. It rehomes over 10,000 animals each year, and in 2008 it introduced "Operation Feline," a program to spay or neuter cats free of charge.

UNITED KINGDOM

The Royal Society for the Prevention of Cruelty to Animals (RSPCA)

rspca.org.uk

The RSPCA was the world's first animal welfare charity, founded in 1824. It works to prevent cruelty, promote kindness to, and alleviate the suffering of all animals. Its centers and branches across England and Wales find new homes for over 70,000 animals each year.

Cats Protection

cats.org.uk

Since its foundation in 1927, Cats Protection has grown to become the UK's leading feline welfare charity. Through its network of over 250 volunteer-run branches and twenty-nine adoption centers, it helps more than 190,000 cats and kittens every year.

Battersea Dogs & Cats Home

battersea.org.uk

Established in 1860, Battersea, in south London, is the UK's oldest and most famous animal rescue center. Every year the home takes in around 13,000 dogs and cats, and it prides itself on never turning away a dog or cat in need of help.

First published 2010 by

Merrell Publishers Limited
81 Southwark Street
London SE1 0HX

merrellpublishers.com

British Library Cataloguing-in-Publication Data:
Kloth, Michael.
Shelter cats.
1. Cats – Pictorial works.
I. Title
636.8'00222-dc22

ISBN 978-1-8589-4523-1

Produced by Merrell Publishers Limited
Designed by Nicola Bailey
Project-managed by Claire Chandler
Printed and bound in China

Jacket, front: K3112 and K3116 (Willie)
Jacket, back (clockwise, from top right): Mulan;
Little Bug; Miss Kitty; Captain Hook; Kitten
Spine: Finnegan
Page 1: Socks
Page 2: Mulan
Pages 4–5: Tiger
Right: Kitten

For information on all these cats, see pages 118–23.

ACKNOWLEDGMENTS
It is with deep gratitude that I thank
Traer Scott for her advice and help with
this project, and Judy Devine-Geuther for
her help week after week at the Benton-
Franklin Humane Society. I am also
grateful for the critical eyes offered by
David Spindler and Amanda Jones while
I was doing the photography for both
this book and my graduate thesis work.
I thank Sandy Davis and Monica Bauman
for pointing me in this direction. Most
importantly, I thank Robin for her love,
support, and encouragement.

A portion of the proceeds from U.S. sales of this book will benefit the American Society for the Prevention of Cruelty to Animals® (ASPCA®)